This book is dedicated to Samuel Shmuelof, who taught me to dream big,
and Rachel Shmuelof, who taught me to work hard
to make those dreams come true.

To Michael Lynn Snyder and Michelle Frohman Roth, for being my lifelong friends.

Also, to Dina and Eli Ron, for creating my beautiful nieces,
Maya and Ariella, who teach me about true love and beauty every day.

I also dedicate this book to all the lovers of beauty,
who embrace the unique qualities that make us stand out,
and everyone who knows how to fake it till you make it!

CONTENTS

INTRODUCTION

How to Fake Real Beauty is the must-have guide for both beauty experts and women of all ages. Who hasn't wished she could improve one of her features and look better? "If only I had thicker hair … bigger eyes … a smaller waist." The list goes on and on.

No one is born perfect, and as a celebrity beauty expert who has beautified Britney Spears, Taylor Swift, Julianna Margulies, and countless other celebrated international beauties, I will share the secrets to enhancing your natural beauty while faking what you don't have. Prepare for the red carpet—whether it's the one in your head or for an actual awards show. This guide will teach you how to get ready for your close-up and confidently take center stage in any situation.

Whenever I'm doing someone's makeup and talk about a tried-and-true makeup trick that I believe has been around for many years and that most people have heard about, I'm surprised to discover that she hadn't known about the trick and is delighted to learn it. I forget that most people are not ensconced in the beauty industry and maybe aren't exposed to beauty pros and information as much as someone in the industry.

or "I never really learned how to do my makeup properly, so I just wing it." All of the above led me to write this book: to share the tips and tricks that I take for granted and to answer the beauty questions I'm most often approached about.

The trademarked philosophy of Ramy Cosmetics is "Minimum Makeup, Maximum Impact!" and it reflects the minimalist approach I've always taken toward beauty. I like a face to look clean, defined, fresh, and pretty. It's not always about a "No Makeup" look, though. You can achieve dramatic, runway, bold beauty looks using this philosophy as well. The idea is that you can achieve it with minimal product and effort.

When I see a makeup artist dragging a giant trunk as a makeup kit, I know he or she is a newbie. With experience, a seasoned makeup artist knows what is essential and important to keep in the makeup kit and what isn't. New makeup artists want to make certain they have every color in the rainbow and four hundred brushes they will never

The trademarked philosophy of Ramy Cosmetics is "Minimum Makeup, Maximum Impact!"

Whenever I'm introduced to someone as a makeup artist, eyebrow expert, or cosmetics executive, the introduction is immediately followed by a question, "How are my eyebrows?" "What do you think of this lipstick color?" Or a statement, "Someone should create a concealer that doesn't crease" (I have!),

use—just in case they might need it! With experience, they learn they can create shades by blending some basic colors and that for all the myriad of colors they have in their kit, there are a few basic shades that they will use 90 percent of the time.

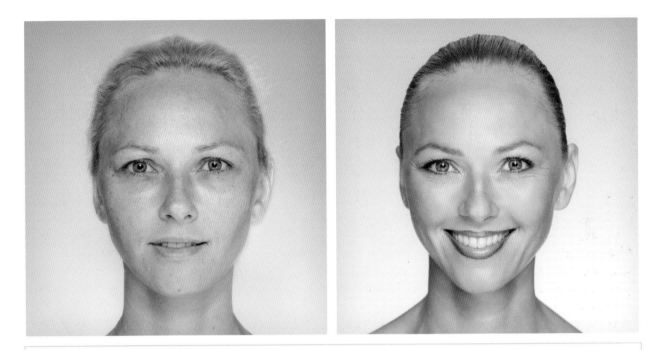

> *The key to "Minimum Makeup, Maximum Impact!" is that you can look your absolute best with minimum product and effort if you choose the most flattering shades and apply them correctly.*

I was on a photo shoot in the Hamptons once, and after shooting all day in a magnificent mansion, the photographer decided that we should change the location to the beach. Since we had already gotten the shots we needed, I assumed the beach shots wouldn't require any major makeup changes so I didn't take my makeup kit with me. Instead I took a handful of powder eye shadows. It turned out that the photographer decided that he wanted to completely change up the model's look once we were on the beach. I completely changed her eye, cheek, and lip color using only my fingers and the eye shadows, and the photographer was thrilled. The key to "Minimum Makeup,

Maximum Impact!" is that you can look your absolute best with minimum product and effort if you choose the most flattering shades and apply them correctly.

The other important point I'd like to make is that your personal taste doesn't always play into faking real beauty. Someone out there thinks that "Tan Mom" looks great. I can show you how to fake a natural, beautiful tan, but if your taste runs to Doritos-orange skin, you may not embrace the information I'm sharing. I've applied makeup on a certain Real Housewife of New Jersey who happens to be really beautiful. When I was done she looked like an A-list movie star, but she wanted me to "Jersey it up" and add more

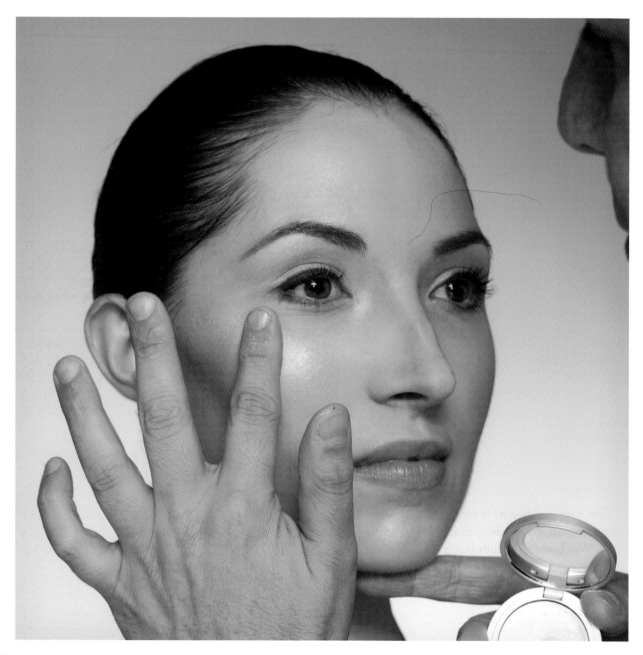

sparkle, garish colors, heavier application. In her case, she knew what her public image is, and I understood that so I (reluctantly) complied.

Earlier this year a young journalist named Esther Honig released the results of an experiment that checked the beauty standards of different cultures. She then released the photos that were Photoshopped in forty different countries, and the results are fascinating. No two photos were the same. Some pared down her look, and some added heavy makeup or changed her features dramatically. It illustrates how the standard of beauty varies widely in different cultures. Some cultures value paler skin; some prefer darker skin; some like thinner eyebrows or larger eyes. My objective is always to create classic beauty where the makeup doesn't draw attention to itself. When I do someone's makeup, I want the result to yield comments like, "Wow! You have beautiful eyes!" or "Gorgeous skin!" not "What's that color you have on?"

It's key to keep an open mind. Follow the steps in this book and test-drive them among your friends and family. The positive feedback will reinforce that you look better than ever and don't need to overdo it in order to look great.

The Beauty Equation

I realized early on that it's the same equation for everyone: whether the face I'm working on is a supermodel or a stay-at-home mom, everyone has features I want to play up and features I want to play down. Everyone.

Yes, beauty is a matter of taste and personal preferences, but there are some universal truths: large eyes are considered more beautiful than small eyes; full lips more sensual than thin lips; a nose that's in proportion to the rest of the

> *The enemy of beauty is complacency. Everyone has beauty potential and the ability to improve her appearance. It's the "Why bother?" attitude that is the undoing of many people.*

The enemy of beauty is complacency. Everyone has beauty potential and the ability to improve her appearance. It's the "Why bother?" attitude that is the undoing of many people. It's that defeatist mindset and the decision not to bother making an effort that result in not reaching your beauty potential.

"Beauty is in the eye of the beholder." We've all heard this classic quote (often followed by "but ugly is to the bone!").

face is more desirable than the alternative. Some people are thought to be born with these natural attributes, but many of these gifts are acquired—whether by enhancing your hair with highlights and deep conditioners, having a rhinoplasty to straighten your nose, or creating an illusion of beauty using makeup and a little moxie.

When I was seventeen I took a year off between high school and college. To save money for college I took a job as

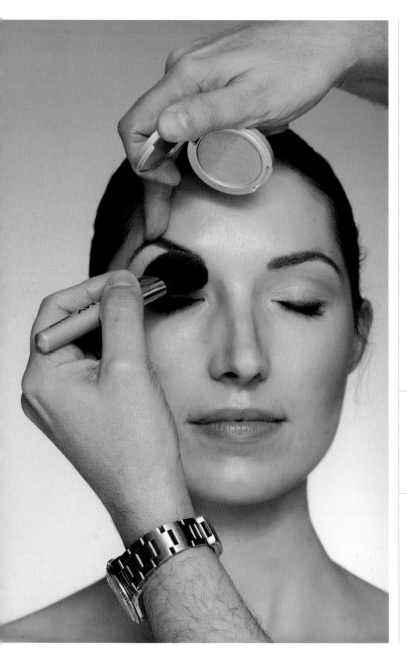

a waiter at the soup bar at the Lord & Taylor department store in Manhattan. One day two gentlemen came in for lunch, and one of them had a sensitive stomach and was very particular about his lunch order. After they ate, he left, and his friend said to me, "Do you know who that was? It was Bill Blass, the designer," and then he told me they were shooting his upcoming collection nearby and would I like to stop by after work? Of course, I leaped at the chance to see a real photo shoot in action. The guy who invited me turned out to be the stylist for the shoot. When I arrived, he took me around the set and introduced me to everyone. The model had already had her hair and makeup done and was dressed in one of Bill Blass's stunning gowns. Her back was to us, and when she turned around to greet us, she took my breath away. She was a goddess—an absolute vision of perfect, glowing beauty. They had me hold up lighting equipment to assist the photographer while he shot the model. Then I followed her like a puppy dog into the makeup room where the makeup artist changed up her look for the next gown. I don't remember the makeup artist at all. I only remember his hands working on her face, making changes to the makeup and, impossibly, making her look even more

The transformation to her face that day was nothing compared to the transformation to my soul. I had discovered the magic of makeup.

beautiful. At the end of the shoot, I walked into the dressing room just as the model was drying her freshly scrubbed face. She lowered the towel and smiled at the shocked expression on my face. "Quite a difference, right?" she said as I just nodded dumbly. With her hair down and no makeup she looked like a fifteen-year-old ordinary girl. The transformation to her face that day was nothing compared to the transformation to my soul. I had discovered the magic of makeup.

After nearly twenty years in the beauty industry, working with some of the greatest talent in hair, makeup, and dermatology and making up some of the most beautiful faces in the world, I've come to the realization that no one is born perfect. Yes, yes, we are all perfect the way God made us, but God also created cosmetics and

Fester from *The Addams Family*: bald, bloated, and with very dark circles around my eyes. I put my knowledge of makeup to good use. My objective was not to look like I had makeup on, but rather to just look like my precancer treatment self. A little concealer, bronzer, and brow filler, and everyone started asking me if I had finished treatment

> *After nearly twenty years in the beauty industry, working with some of the greatest talent in hair, makeup, and dermatology and making up some of the most beautiful faces in the world, I've come to the realization that no one is born perfect.*

good lighting! Even the most beautiful person has to draw attention away from one feature and play up another to look her best.

In 1998 I was working as makeup director at a top Fifth Avenue salon in New York City, where the pressure to look good was intense. The salon staff was gorgeous. Like many who work in the beauty industry, we all enjoyed the perks of working in a top salon—getting haircuts, changing up hair color, and enjoying facials and manicures on a regular basis. My job at this salon really jump-started my career. I started working on celebrities, did makeup for runway shows and editorial photo shoots and became well known for eyebrow-shaping thanks to my first mention in a story about eyebrow obsession in *Vogue*. Then I was diagnosed with Non-Hodgkin lymphoma. It was caught early and my prognosis was excellent, but I had to go through five months of chemotherapy and then one month of daily radiation to prevent a recurrence. Being young and driven, I opted to continue working and took just one sick day during chemo. Suddenly, the pressure to look good intensified. I was open about my situation so my clients and coworkers were aware and very kind and supportive. Suddenly, I looked like Uncle

(I hadn't) instead of tilting their heads sympathetically and asking me how I was feeling. This made me realize not only that makeup has the power to make you look and feel better, but also that makeup has the power to truly transform a person and how we are perceived by others. After all, in a few simple steps I was able to fake looking healthy while living with cancer!

I started volunteering to give makeup lessons to people living with cancer. I never failed to be struck by how even someone undergoing chemotherapy—with no eyebrows or eyelashes and a sickly complexion—could easily be transformed into a beautiful and glowing picture of good health. I published *Beauty Therapy: The Ultimate Guide to Looking and Feeling Great While Living with Cancer* (M.Evans/ Rowman & Littlefield, 2005) to help share the knowledge with people who are living with cancer and aren't makeup artists. Suddenly, makeup wasn't just fun and sparkly. It was a powerful tool that could change someone's mindset during a life-threatening illness. The power of makeup: faking the appearance of good health. I realized then that everything can be faked: better hair, better skin, and ravishing beauty! It's all a matter of knowing how.

I have been a student of beauty my entire life. I remember admiring my mom's gorgeous eyebrows when I was four years old and having a general distaste at age seven for her overly made-up friend who also had bad hair. Why is one thing visually appealing and the other not? Why does one color make me feel happy and the other sad? How do these things affect everyone around me?

There was a great deal of beauty in nature, but as far as people were concerned, well, even Cinderella needed a makeover before she could go to the ball.

I'll never forget one of my first makeup clients at the salon. I didn't see her until after she had her hair colored and cut. The hair was fabulous, gorgeous blonde. Her makeup, on the other hand, looked like she was a retired Rockette from Radio City Music Hall. She had frosted blue eye shadow, heavy black eyeliner, and false eyelashes so big and thick that you literally could not see the color of her eyes. Top it off with hot pink blush and fluorescent-dayglo, nuclear-pink grandma lipstick, and all I could

heavy makeup that masked her natural beauty instead of enhancing it. I thought she might not have eyelashes, but she did, and they were long and lush and she didn't even need false lashes. She said she started wearing makeup at fifteen growing up in Texas and basically just stuck to the same routine all her life (beauty rut!). Her boyfriend and family always told her that the makeup was too heavy, but she never knew how to change it. It was all or nothing. I introduced her to warm neutrals and my minimalist approach to makeup.

The results were amazing. Suddenly you could see her big blue eyes and high cheekbones. You noticed her beautiful complexion, not her makeup. I knew that if I'd used a nude or lip-toned lipstick, she would feel too bare-faced, so I applied a rich burgundy. She still felt naked because she was used to nuclear-hot pink lipstick. I encouraged her to wear the burgundy lips for the day to get used to it. The next day she returned to buy the burgundy lipstick because she received so many compliments on the color.

> *Having worked with many celebrities. actresses. models. and socialites. one thing has become crystal clear to me: even the most stunningly beautiful woman in the world is not perfect.*

see was someone who needed my help. To my surprise, when I gently approached her to suggest a makeup lesson, she was all for it. She said she would come in the next day to see me. True to her word, she came in the next day. I told her to come in with no makeup on and she did—but she hid her face behind a giant hat and big sunglasses. I braced myself to see what was beneath the accessories. To my complete shock, when she removed the hat and glasses, she revealed a face that was stunningly beautiful. I couldn't believe it and asked her why she wore such

Having worked with many celebrities, actresses, models, and socialites, one thing has become crystal clear to me: even the most stunningly beautiful woman in the world is not perfect. Everyone has natural gifts, and everyone fakes the rest. Some fakes are obvious—overblown lips, extra-large breast implants, over-processed hair—but the smart ones know how to fake it so that it looks like the pure gift of natural beauty.

Early on in my career, I quickly learned that even the most sought-after beauties don't wake up looking flawless.

Much of the end result we see requires the right makeup, skin care and hair tricks, strategic clothing, correct posing, and much more. The words "It takes a village" were never truer than as they apply to beauty, as any actress or model like, "Well, if you want to look like you're from New Jersey . . ." or "Supercuts is up the block" as you'd see the client shrink visibly in their chair.

I find that in the beauty business there are beauty bul-

The philosophy behind this book is not about being artificial. It's about polishing your natural beauty by enhancing your assets and learning how to believably perfect your features.

will attest. Since I routinely work on "real" people as well as celebrities, I realized that most people have the misconception that celebrities roll out of bed looking perfect and stunning while the rest of us mere mortals must simply make do. The truth is that these "perfect" celebrities work very hard to create that illusion. The real difference is that actors and models have access to the experts who know how to fake whatever is necessary to create that flawless image.

Beauty Bullies

At one of my first jobs at a cosmetic counter there was a makeup artist who would sell a great deal of products, but also had the most returns. The reason? He would bully customers into buying products that were out of their comfort zone and that they knew they would never actually use. I would hear him asking a woman who clearly never wore any makeup beyond lipstick if she uses concealer. When she said no, he'd reply with "Oh honey! You can't live your life this way!" The customer looked beyond uncomfortable but would buy everything just to make good her escape. When I worked at a color salon, the lead colorist would say things

lies that tear you down instead of building you up. Whether it's to make a sale or to thrust their opinion on you, it's a very negative approach. Beauty should build you up, make you feel more confident, and, most important, make you feel like your best self. If you find yourself in the hands of a beauty bully, run. Walk away from the counter, get out of the chair, and take your business elsewhere to someone who will lift you up and offer you a positive experience. The colorist at the salon might have known what would look best on his client, but he could have relayed the message without belittling her or making her feel ridiculous.

As someone on the inside with a love of all things beauty related, I have always paid attention while working on photo shoots, backstage at runway shows, and at TV studios. In *How to Fake Real Beauty*, I share the very real tried-and-true tricks of the trade.

BeYOUtiful

The philosophy behind this book is not about being artificial. It's about polishing your natural beauty by enhancing your assets and learning how to believably perfect your features.

chapter one _____

HOW TO FAKE

A PERFECT
COMPLEXION

Meet Our Model >

IRENA is easy-going and completely without ego. She put herself in my hands and demonstrates how even a professional model can use the Beauty Equation to perfect her appearance.

One of the most frustrating beauty problems that exists regardless of age: acne-prone skin. Nothing makes you feel more helpless or undercuts one's confidence than a blemish or, worse, an outbreak of pimples. While there are topical solutions both over the counter and by prescription like Retin-A, as well as the more serious prescription medications, like Accutane—this book is about what to do when there is no time to wait for the meds to kick in and you need to look flawless *now*.

First, though, we have to talk about what makes your skin break out in the first place. Of course there are many factors that affect your complexion: diet, stress, environment, and hormones are just a few factors that can cause you to break out. However, taking good care of your skin can help.

As I like to say, cleanliness is next to goddess-ness when it comes to good skin. Keeping your skin clean is the best way to minimize breakouts and help keep your complexion clear. Cleansing in the morning is important, and we all know the golden rule is to remove makeup and wash your face before bedtime, but during the day sometimes you may need to touch up as well. I like to keep anti-acne pads in my office for a midday pick me up. At night, no matter how tired I might be or how late I get home, I will never go to sleep without cleansing my face. If I don't have the energy to formally wash my face, I'll either use an astringent with a cotton round or a pre-moistened cleansing cloth.

Opt for products with skin-clearing ingredients, because even if your skin is clear, this ensures it will stay that way and act as a preventative measure. Choose cleansers with ingredients like salicylic acid, benzyl peroxide, alpha or beta hydroxy, or glycolic acid. Also use a moisturizer or tinted moisturizer with salicylic acid and skin-clearing ingredients. These types of active ingredients also have great anti-aging benefits by keeping skin exfoliated and diminishing fine lines.

Solutions to Achieve Blemish-Free Skin

DRY IT

You definitely want to dry the blemish, but just the blemish! The common mistake people make in their panic to clear away the unsightly spot is to dry out their entire face in the process. There are several options to use to dry a blemish and speed up its demise: the obvious, over-the-counter remedies, like Clearasil or Clean & Clear. Apply only to the blemish, not to your entire face.

If I'm applying makeup on someone with a zit, or if I have an event or on-camera appearance and a blemish pops up, my secret weapon is rubbing alcohol. Witch hazel works well, too, but nothing will dry a blemish faster than dabbing rubbing alcohol on it with a cotton swab. Repeat as necessary, but be aware that overdoing it might also redden your skin temporarily. That's not an issue if you have makeup to cover the redness, and the pimple's lifespan will shorten dramatically!

ZAP IT

There are many devices now available for at-home use that zap a blemish with a low electric current to dry the pimple and speed up the skin-clearing process. The heat from the device will kill bacteria and dry the blemish. These devices claim to clear skin within twenty-four to forty-eight hours and are recommended for mild to moderate breakouts. I find they do speed up the healing time of very mild blemishes, but not significantly enough, and they are not recommended for subclinical acne (barely visible blackheads or whiteheads), comedonal acne (blackheads and whiteheads with slight inflammation), or severe nodular or cystic acne. If you have a stubborn pimple, the heat from these types of devices may help speed up the demise of the pimple, but not fast enough or dramatically enough to warrant the purchase price, which can range from $99 to $299. Topical solutions are far more effective.

Exfoliate It

Using a sonic brush with an exfoliating cleanser truly speeds up the healing process and helps skin turn over and heal much faster. I swear by my Clarosonic brush and use it almost daily. If I have a blemish, the brush helps clear it away much faster than it would normally. For sensitive skin, opt for a cream or gel cleanser with a brush. For tougher complexions, use a scrub with the brush for serious exfoliation. Ridding the skin of dead surface cells also makes your skin more receptive to acne treatments to further banish blemishes. When using a sonic brush for the first time, follow

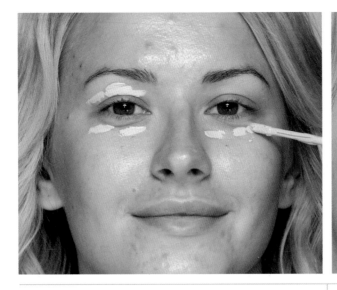

the instructions in the package. Use it with a very gentle cleanser and a gentle hand to ensure you don't irritate your skin or overdo it. Once you see how your skin responds, you can proceed to either use it daily or on alternate days. A sonic brush is very effective, but you can also exfoliate without one. Use a facial scrub instead of your cleanser once or twice per week or use a wet facial towel with your cleanser. The key is to add a product or tool with a scrubbing texture that will slough away the dead surface skin and reveal the layer beneath it.

PRO TIP: Dermatologist David Bank says, "Pockmarks are dented scars left behind by acne. To help reduce their appearance, exfoliate regularly, try microdermabrasion to generate new layers of skin, and use a retinol cream to boost cell regeneration. For a more effective way to get rid of pockmarks and other acne scars, ask your dermatologist about lasers like Fraxel."

Source It

Don't assume a breakout is simply from stress, diet, or hormones. Think about anything you've changed recently that may be causing a reaction in your skin. Using a new hair product? A new conditioner, shampoo, or leave-in hair product can cause a reaction where the hair touches your face. Trying a new detergent or fabric softener? Your face on that pillow could be the source of the outbreak. Do you use your cell phone frequently? Think about the dirt, oil, and bacteria that your phone comes in contact with. Then you hold it against your face. It's good to disinfect your phone with rubbing alcohol every few days as a preventative measure.

I once had a client come in for a makeup lesson. She told me she'd tried every brand of cosmetics and skin care and everything made her break out. Part of the lesson was assessing her existing makeup. As she pulled products out of her makeup bag, she pulled out a blush brush that

was so dirty I wouldn't clean my toilet bowl with it! I asked her how often she cleans her brushes. "Clean my brushes? Never," she replied. She'd been using that brush for years, and it turned out to be the source of her acne.

Another client was using a very high-quality brand of foundation, concealer, and powder. When I looked at the powder compact, the powder was green. I asked her why she was using a green powder, which is usually used to counteract redness, which she did not suffer from. She said, "It's not green, it's translucent and looks white in the compact." I showed her the green powder. It turned out that she had spilled something in her purse, the powder had gotten wet, and mold had developed. She unwittingly kept using the powder and it caused her skin to react. Granted, this was a freak accident, but the point is to consider what your skin is coming in contact with. That awareness and a good cleansing regime can save you lots of heartache as well as money spent on products and dermatologists.

Attack It Internally

I have seen clients who had terrible acne all over their face and were trying everything under the sun to clear their complexion, to no avail. Then one day, they walk in with perfectly clear skin. In a few cases, there was no sign that they had ever had acne. I had to know what they did to have such a complete transformation in their complexion. In one case, she started drinking at least eight cups of green tea daily. In another case, he discovered he was allergic to a food he was eating on a regular basis, and when he eliminated it from his diet, his skin cleared up. I'm not saying green tea is a miracle solution for everyone. I'm saying look at your diet and maybe go in for an allergy test. Don't assume that your breakout is simply the result of stress or genetics.

Medicate It

In extreme cases, when you have truly severe acne, sometimes the best solution is prescription medication, like Accutane. I've seen astounding results from Accutane use when all else has failed. That said, it really should be used only when you've exhausted the other solutions and are under the supervision of a trusted dermatologist. While Accutane can be a miraculous solution, it can also cause excessive dryness, peeling, and redness. It is a serious drug that can only be prescribed twice in your lifetime because it can be rough on your liver. You need to be off of Accutane for a full year before trying to get pregnant, so clearly it is a strong medication that should not be taken without serious consideration.

PRO TIP: Cheryl Kramer Kaye, Executive Beauty Director of *Shape* magazine says, "Okay, my best tip that I share with almost no one because it's so freaking random: when I see or feel a zit coming on, I dab it with a drop of Purell about once an hour. The alcohol kills the surface bacteria and dries the spot, so the blemish never really blooms."

Addressing Poor Pores

Diminishing the size and visibility of pores has become an industry unto itself in the beauty world. I once received an e-mail from a woman asking for my advice on how to reduce her pores. She told me she went for weekly facials, used scrubs daily, and did everything one should do to diminish the appearance of pores, yet her pores remained huge. I told her to get rid of her magnifying mirror. She was clearly obsessing too much about her pores and looking at her skin too closely. She had lost perspective. She wrote back to thank me and wondered how I knew she was using a magnifying mirror? Once she took a step back, she realized her skin looked great.

Many skin-care brands offer products to shrink pores, deep-clean pores, or hide pores. Pores are the bane of complexion-obsessed people. If you are maintaining your complexion with regular exfoliating and anti-acne or anti-aging products like Retin-A, you are already diminishing the look of your pores. The fact is that you cannot actually shrink a pore. Pores do not contract and expand. A pore on an oily, unclean face may appear more visible if there is dirt in that pore, but it is not, in fact, any larger than when that pore is clean; it's just calling attention to itself when it's unclean. Regular cleansing and exfoliating and a good toner, like Clinique Clarifying Lotion (Scruffing Lotion for Men) will keep your pores less visible.

I also advocate using pore strips once per week. While they make pore strips for areas of the face like the chin and forehead, the only area where pore strips will really make a difference is the nose area, where pores are larger and more visible than other areas of the face. It's always shocking and satisfying to see what comes out of your pores and onto the pore strip.

Many new products, including primers, BB and CC creams, and foundations today are formulated to diminish the appearance of your pores. Odds are that if you keep your complexion clean, remove your makeup at the end of the day and exfoliate, then your pores will not be an issue. Any procedure at your dermatologist's office that removes the surface layer of skin, like a chemical peel or microdermabrasion, will also help to significantly diminish the visibility of your pores. If you still have an issue with pores looking too visible when you have makeup on, use a primer under your makeup. It will help the makeup glide over your skin instead of settling into pores.

Steaming your complexion will help clear your pores and make them less visible. You can steam your skin at home by filling a pot a quarter of the way full with water and bringing the water to a boil. Turn the heat off completely. Hold a towel over your head and lean your face over the pot so that you feel the steam on your face for a few minutes. Follow up by splashing your face with cold water. If you have access to a steam room, a few minutes two or three times per week will make a wonderful difference in your complexion.

PRO TIP: *Health* magazine's Beauty Editor, Aviva Patz, says, "For great, hydrated, balanced skin, don't wash your face in the morning. Just splash with water and apply a mild (non-alcohol-based) toner. This trick, while it feels rebellious, has totally transformed my oily skin. By not using cleanser, my skin doesn't get over-dry, which means it doesn't crank up oil production to compensate. I also save a few minutes in the morning!"

Fake It with Makeup

The key to concealing a single blemish or pimple is to use a moisturizing, highly pigmented concealer in a warm (yellow-based) tone. Choose a shade that either matches your skin tone exactly or is one shade lighter. Test the shade by drawing it along your jaw line. The perfect shade will be undetectable and invisible. If you can see the color swatch on your jaw line, the shade is too light, too dark, or has the wrong undertones. A good trick is to apply acne medication directly onto blemishes before applying concealer. The medication creates a protective barrier while continuing to speed up drying the blemishes under the makeup.

STEP ❶: Apply the concealer directly onto the pimple.

STEP ❷: Blend so that the blemish and surrounding area are covered. If you blend slightly and the concealer doesn't hide the blemish, then the concealer may be too sheer.

STEP ❸: Blend well—not so well that the concealer is wiped off, but enough so that the concealer and pimple are undetectable.

STEP ❹: Set the concealer with translucent powder so that the concealer stays put. Some people prefer using loose powder, but for concealing pimples, I prefer pressed powder because you get less powder on your skin and avoid the over-powdered, caked-on look that can draw attention to the blemish as opposed to concealing it.

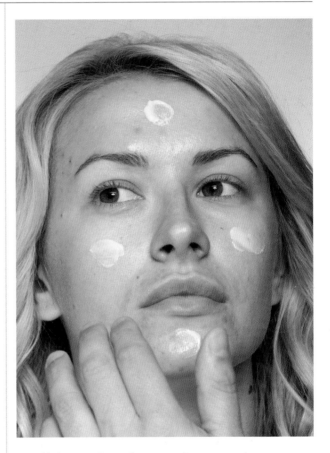

If the pimple you're concealing is raised, a moisturizing or liquid concealer is best. If the blemish is not raised, you can opt for a heavier concealer or foundation stick, which will offer more coverage.

before

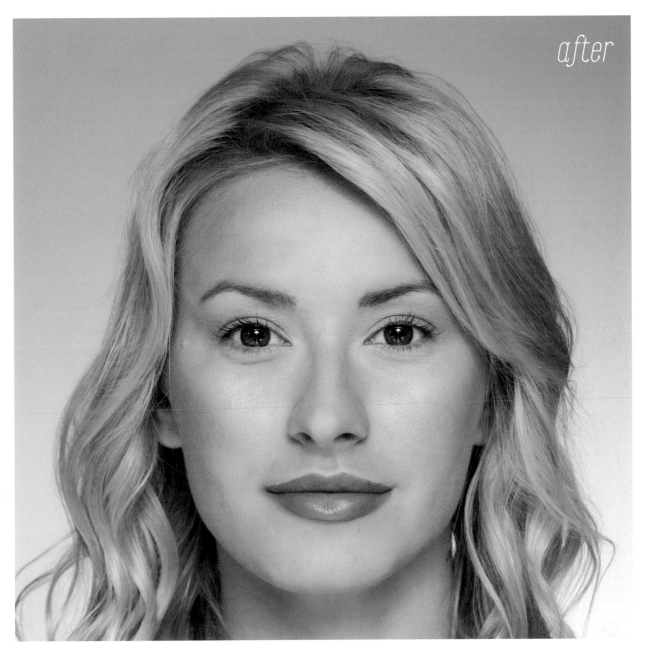

after

Concealers to try:
Neutrogena SkinClearing Blemish Concealer, $9.99
Ramy HD Skin Stick Concealer, $24
Chanel Correcteur Perfection, $40

Pressed powders to try:
Revlon PhotoReady Translucent Finisher, $12
Ramy Pure Radiance Pressed Powder, $24
Clé de Peau Beauté Refining Pressed Powder, $105

Facing a Full-Scale Breakout

Definitely opt for cleansers and creams that target acne as they do help to clear breakouts. Be careful not to over-strip your skin in your zest to eradicate your acne. Complexions never look better when you add redness, dryness, and flaking to the mix. Overdosing on an acne treatment won't speed up the process, and over-drying your complexion will only cause you to produce more oil and irritate your skin. Use products sparingly, and fake a flawless complexion using makeup.

When in breakout mode, stick to makeup that has a cream or matte finish as opposed to shimmer or luminizing products. While it's okay to add a shimmery eye shadow or lip, avoid iridescence in your foundation, facial powder, and blush as they will draw attention to skin imperfections like pimples. A more matte finish will create the illusion of a smoother, flawless complexion.

STEP ❶: Apply the concealer around your entire eye area to conceal dark circles, redness, and to act as a primer for the eye makeup and visually bring your eyes forward.

STEP ❷: Spot check with the concealer, adding it only to the most glaring blemishes or red spots. Blend well.

STEP ❸: Apply a liquid or liquid-to-powder foundation where needed on your face and blend. The key is *not* to apply a full face of foundation like a mask, but rather, apply lightly where you need less coverage and more heavily where you need more coverage. Blending well and using a yellow-based shade are key for a believable and flawless finish. Yellow-based foundation will also do a better job of counteracting any redness.

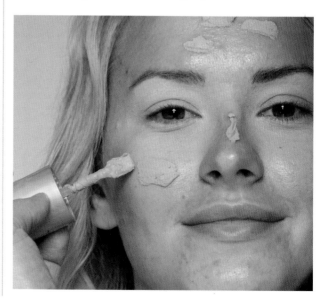

STEP ④: Set the foundation with a light pat of translucent pressed powder.

STEP ⑤: Apply a matte, powder blush in a nude or peach shade to your cheeks, along your hairline, and (optional) across your eyelids. This creates the illusion of a smoother complexion. If you've covered a pimple with concealer or foundation and there is still a visible bump where the blemish is, a matte, nude blush will make it much less visible.

STEP ⑥: Create a diversion! Choose a feature on your face to draw attention to: bold eyeliner on your eyes or a bright lip color will draw attention to itself and away from any skin imperfections. I call this a diversionary tactic, and it truly works!

Foundations to try:
Neutrogena SkinClearing Liquid Makeup, $11.99
Ramy Elixir Liqui-Powder Foundation, $39
Crème de la Mer The Treatment Fluid Foundation, $85

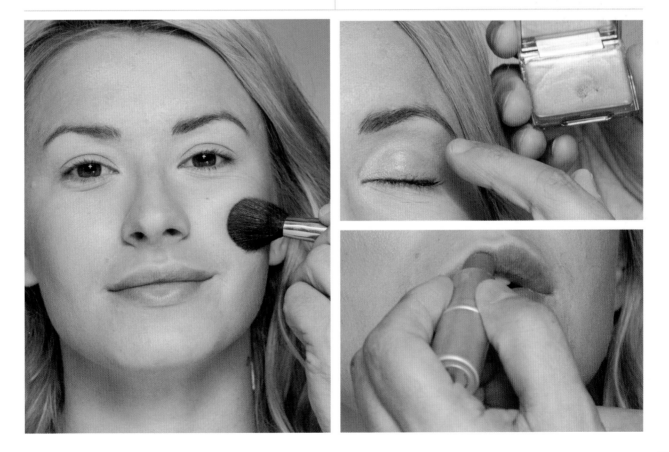

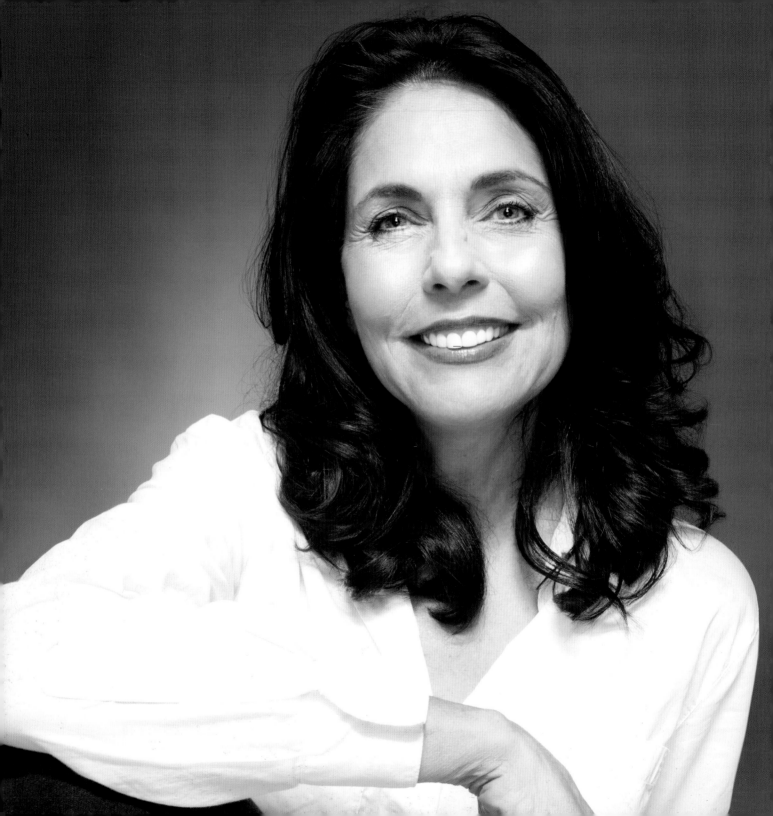

chapter two _____

FAKING AND MAINTAINING

A YOUTHFUL FACE

< Meet Our Model

CELESTE has been my client for over fifteen years. She's a model, a mom, and all-around spitfire! Having just turned sixty, Celeste is a great example of how you can look vibrant and beautiful at any age.

When I was launching Ramy Cosmetics, I approached Bergdorf Goodman to carry my line. It took about one year of meetings with the buyers before finally launching my brand at the legendary department store in 1999. During one of those meetings, the head buyer held out both of her hands and said, "Look at the difference." One hand was flawless; the other had age spots, discoloration, and redness. It looked like something had happened to that hand. The buyer said, "Nothing happened, but for twenty-five years every time I met with a skin-care company, I would try the products on this one hand." A variety of different products, all different brands and price points, had come into contact with that hand. The hand she sampled the products on remained youthful. The other hand aged. Visually, it was rather dramatic, and the lesson was that it doesn't matter which brand you use or which particular product, but rather the act of caring for one's skin—exfoliating, moisturizing, using sunscreen—can make a dramatic difference in the aging process.

Care for the Skin You're In

It's not about expensive or inexpensive when it comes to skin-care products. It's about what works best for *you*. Most people end up using a mix of both high-end and mass products, and that's fine. It's the end result that counts. The most important factor is consistency. Find your routine and do it on a regular basis; otherwise, even the best products in the world won't do much for you.

EXFOLIATE

Whether you use a scrub instead of your usual cleanser a few times per week or use a Clarosonic brush to cleanse your face, exfoliating makes a huge difference for maturing skin. It gets rid of the dull surface skin and reveals the younger, fresher skin beneath. This has the added benefit of preparing your skin for any anti-aging product you apply afterward. There are a myriad of different scrubs available on the market. They all work well, and it's really a matter of personal preference which to choose. The active exfoliating ingredient can be sugar, salt, apricot seeds, anything that adds a "scrubbing" effect to the formula and will slough off dead skin cells. I like a scrub that has other active ingredients as well, like anti-acne or anti-aging ingredients. I've encountered many people who look great, but have dull skin with lines that are not from age, but rather from dryness and lack of exfoliation. Adding a facial scrub to their face-washing routine twice a week and applying a moisturizer can shave a decade off of their appearance!

PRO TIP: Amy Keller Laird, Editor-in-Chief at *Women's Health*, says, "When washing my face in the shower in the morning, if I'm using a cleanser with some type of active ingredient—say, glycolic acid to smooth roughness, or salicylic acne for zits—I massage in the formula and leave it on my skin for thirty seconds to a minute before rinsing. That way, I give the ingredient a chance to penetrate. It helps make the cleansing process a treatment as well."

Cleanse

While scrubbing will exfoliate and cleanse your skin, you should only exfoliate one to three times per week. The rest of the time, use a gentle cleanser. If you wear makeup, remove makeup first with a makeup remover or pre-moistened cloth, then follow up with a gentle cleanser. Remember that your complexion does not end at your chin. Whatever you do for your face, extend it to your neck, ears, even the back of your neck—this goes for cleansing, exfoliating, and any anti-aging or skin-clarifying products you use.

TREAT

There are wonderful topical solutions that can make a huge difference in the appearance of your skin. Wrinkle relaxing creams act like topical Botox by filling fine lines and wrinkles like spackle. Serums with hyaluronic acid can plump the skin for a more youthful appearance. Prescription-strength Retin-A can work wonders to eliminate fine lines and wrinkles. If your issue is age spots, there are many spot-reducing products that work well. The key to anti-aging skin care is consistency. Whatever product you use to address a particular issue, use it on a regular basis, and you will see long-term results. Keep in mind that that when you exfoliate or use Retin-A, you are removing the surface layer of skin. This makes your skin more susceptible to sun damage, so it's imperative to wear sun protection during the day so that you don't invite more sun damage or premature aging.

Wrinkle relaxers to try:
Alcone Paramount Wrinkle Smooth, $8.99
RoC Complete Lift Lifting Firming Daily Moisturizer, $32
Ramy Freeze Frame Wrinkle Relaxer, $85
Freeze 24-7 Instant Targeted Wrinkle Treatment, $95

PRO TIP: Dermatologist David Bank says, "For existing lines, age spots, and wrinkles, try a serum or moisturizer that boosts collagen production and skin cell turnover. Products with vitamin C and antioxidants can help fade dark spots, brighten skin overall, and help fight free-radical damage in the environment. Retinol moisturizers can also help reduce fine lines by boosting collagen and skin cell regeneration."

Mask

Masks offer more intensive ingredients to address a variety of issues. Clay masks can help cleanse pores and control oil production; moisturizing masks help to alleviate excessively dry skin; and vitamin-C masks help to improve skin clarity and brightness. There are masks to address most complexion issues. The higher concentration of active ingredients than are in a regular cleanser or moisturizer, and the fact that you leave the mask on for a minimum of ten minutes help to provide dramatic results. While masks are not usually part of a daily skin-care routine, they are a great

addition to apply once or twice per week or whenever you want to treat your skin to a boost and take a few minutes to relax. While masks are great at any age, at a certain age masks can make a great difference in the quality of your skin.

Protect

An ounce of SPF can prevent a pound of skin damage. It's better to prevent skin damage and premature aging than it is to try to repair it. Dark tanning oil with SPF 4 is not sufficient sun protection. Apply at the very least an SPF 15 and reapply if you think you've sweat it off during the day. If you want to avoid an additional step, opt for makeup or tinted moisturizer with SPF in it. Continuous daily use of a broad spectrum SPF can prevent or minimize age spots, discoloration, wrinkles, and lines. It also protects us from skin cancer. I find that I tan even with SPF 50, which means the sun's rays can do damage even with a high SPF.

MOISTURIZE

Many times I've met people who looked surprisingly older than their actual age. They ask my advice about whether or not I think they need Botox. More often than not the answer is no. I can see the dead surface skin on their face, and the lines or wrinkles are not from age, but rather from dryness. I tell them to use a scrub twice a week and then moisturize once in a while when their skin feels dry. The transformation is unbelievable and takes years off of their appearance. Your skin type and what climate you live in determine how often you need to moisturize. Assess your skin daily. One day you may look and feel dry, and the next you may not. Apply moisturizer when you feel you need it. If you're using an SPF daily, just make sure it's a moisturizing formula.

RAMY PRO TIP: **After cleansing your face in the shower, apply a night cream or intensive moisturizer and leave it on your skin while you shower. Rinse it off before exiting your shower. The combination of freshly cleansed skin and the heat and moisture from the shower will make the cream more effective and leaves your complexion beautifully conditioned.**

Use Oil

A few short years ago, oil was a dirty word in the beauty industry. Everyone wanted every product that touched their face to be oil-free. Clients would nearly jump out of the chair as I was about to apply foundation because they had to know it was oil-free first. Today we know that oil-based products can be a natural and healthy wonder for your skin and hair: Moroccan oil, argon oil, and coconut oil have become part of our beauty vernacular. Oil-based hair conditioners and facial cleansers are amazing options, especially as we mature because they add youthful moisture to hair and skin without stripping natural residue. If you suffer from dry hair or skin, oils can be your gentle but transformative best friend.

Speed Dial Your Derm

A dermatologist can be invaluable. The good ones care about your overall health and not just shooting you up with fillers. Your dermatologist can advise on more serious treatments for your complexion: lasers to remove age spots and to tighten skin, Botox or fillers if needed, serious prescriptions for acne. The real secret to a more youthful complexion, however, is maintaining your skin by addressing issues as they occur and routinely following a good skin-care regime.

PRO TIP: *Good Housekeeping's* Beauty Director, April Franzino, says, "Get a 'facial' (in your shower). A few times a week when I shower, I apply a layer of a face mask before stepping in, let it work while I wash up, then rinse before getting out. It not only saves time, but the shower's steam helps the ingredients penetrate. Because who really wants to sit around while their face mask sinks in?"

Injectables: The Pros and Cons

Botox will probably go down in history as the greatest beauty breakthrough of our time. Fillers like Juvéderm, Restylane, and Perlane are close runners-up. Every day, new and improved fillers hit the market, promising to last longer and offer more natural results.

Botox is most often used between the eyebrows, smoothing frown and expression lines. Fillers like Juvéderm can be used to refill the volume lost in the face due to the natural loss of collagen from aging. These are game changers that did not exist forty years ago. Today, fifty-five-year-old actresses are standing next to twenty-year-old actresses on the red carpet, looking every bit as beautiful.

The Golden Rule for injectables: I've seen many friends and clients before and after they've been injected.

The key to astounding results is moderation. In my opinion, no one should ever get injected more than twice per year. Any more often than that and the results look obvious and artificial, even if you are being treated by the most renowned dermatologist. With fillers like Juvéderm, for example, the effect will fade after several months, but a pool of filler remains and when you reinject the same amount in the same spot, the result is more exaggerated than the first time because the filler hadn't fully dissipated. It's a slippery slope, but if you inject again too soon, you may end up looking overdone. In my opinion, your objective with injectables is to smooth and restore your face to its previous youthfulness, not to create an entirely new visage. If you've changed the shape of your face with injections, you've gone too far.

PROS

- Injectables can truly take years off of your appearance.

- Botox can prevent future lines and wrinkles.

- Fillers like Juvéderm and Restylane can replace lost volume and eliminate deep folds and lines.

CONS

- When you try Botox or filler on one area of your face, the rest of your face doesn't look as good. It's like painting one wall in a room. Suddenly the other walls look shabby. This phenomenon makes you focus on the areas of your face that you did not have injected.

- If you get injected more than once every six months, you run the risk of looking like a blowfish. It becomes obvious and artificial looking.

- Looking overly plumped up and smooth is the new "old face." When a child sees an overly injected face, that's Grandma—the way we saw gray hair and wrinkles as old when we were children.

- If administered incorrectly, injectables can have adverse effects. Botox can over-lift the brow, or worse, push the brow downward. Fillers can distort your cheeks or jawline if injected in the wrong area or overdone. If poorly executed, filler can shift from one area of the face to another. I've seen what started out as high cheekbones from filler shift downward and look like chipmunk cheeks.

PRO TIP: Dermatologist David Bank says, "There are many pros of Botox and other fillers. When creams, masks, and other topical treatments aren't cutting it anymore, fillers can help reduce wrinkles, restore facial volume, and diminish frown lines. Newly FDA-approved filler, Juvéderm Voluma, restores facial volume and lifts cheeks for a more natural and younger look overall when used in conjunction with traditional fillers such as Restylane. There is also little recovery time compared to face-lifts and deep chemical peels. Of course, there are cons to fillers as well. It's easy to get carried away with too many fillers, and the outcome looks overdone and unnatural."

How to Fake the Look of Fillers Using Makeup

While no makeup can offer the long-term results of Botox injections or fillers, you can emulate the look of injectables using makeup to create a smoother complexion and more youthful appearance. It's simply about filling lines and wrinkles topically with wrinkle relaxing cream and primer and then adding a concealer that is a shade or two lighter than your skin tone directly on any line or wrinkle to decrease its depth. And add a youthful glow with my Youth Recipe Blush (see page 41).

STEP ❶: Apply wrinkle relaxing cream directly onto any line or wrinkle—the "number 11" lines between your eyebrows, the nasal labial lines, and anywhere else on your face that has a line or wrinkle you want to address. Blend along the line or wrinkle so that the cream fills the area like spackle. Wait one or two minutes for the wrinkle cream to set and dry.

STEP ❷: If your skin is normal or oily, skip this step. If you have dry skin, apply moisturizer to your entire face and neck area.

STEP ❸: Apply a primer to your entire face and neck. The primer locks the wrinkle relaxer and moisture in place, and helps the makeup go on smoother and wear longer.

STEP ❹ : Apply a concealer that is two shades lighter than your skin directly onto the lines or wrinkles, on top of where you applied the wrinkle cream. Blend back and forth.

STEP ⑤ : Set the concealer with a translucent powder. If you are applying foundation or tinted moisturizer, do that first and then set your entire complexion with powder.

STEP ⑥ (optional): After the above steps, you can add more concealer directly onto your problem areas to further "fill" them and create an even smoother complexion.

How Makeup Can Be Used to Fake a Younger Face

Think: moisturized, and light and strategic application. The days of wearing an eye shadow or lip color because it's pretty in the package or appealingly sparkly are over. As a makeup artist, I've always studied faces and am intrigued by why someone looks twenty, thirty, or sixty years old. What are the differences in the person's face that cause them to no longer look twenty-three? I've noticed some universal truths of the aging process:

• Eyelashes get shorter

• Eyebrows get skimpier or longer, or both

• The face loses fullness and volume due to diminishing collagen

• The lip line becomes less defined

If your objective is to look naturally younger and fresh, follow these steps, and people will start asking you if you've had work done.

Assess and Address

If you truly want to look younger and more beautiful, it's very important to assess yourself as objectively and honestly as possible. Check your ego at the door. Look at your bare face from two feet away from the mirror as though you are seeing that person for the first time. Then move in closer to the mirror. What are you seeing that you like? That you dislike? What has changed over time? An honest appraisal is your best friend. Knowing what you need to address and improve is the first step toward achieving and maintaining your best appearance and self.

If you find it difficult to look at yourself objectively, take a selfie with your phone and use the selfie to assess yourself. For some reason, people are more objective

before

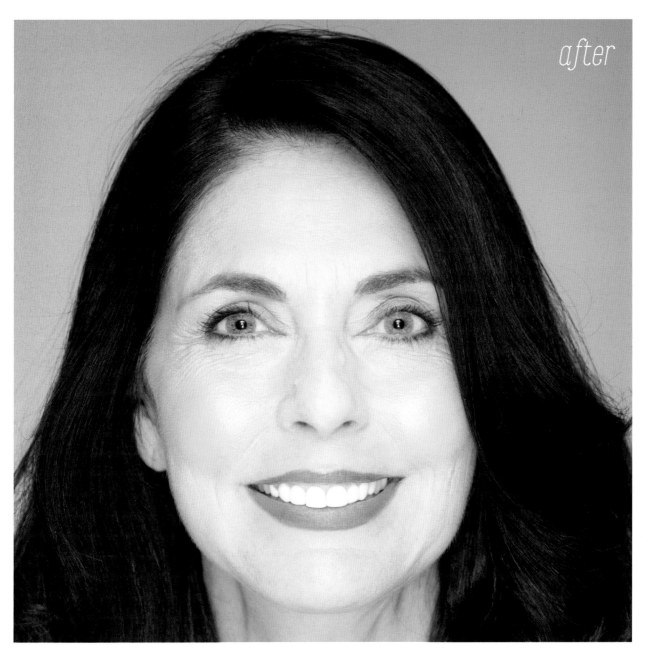

after

when they look at a photo of themselves than when they look in a mirror. Usually the feature you hate most (we all have one) is your best asset. Whether it's your nose or lips, it's usually what sets you apart from the crowd and what makes you memorable. So when you're assessing, don't zoom in on that one feature, but rather look at your face with as much objectivity as possible. This is an important step in creating your best image.

Prep Your Canvas

Apply a primer all over your face and neck. A primer will lock in moisture, create a smoother surface, and help the makeup go on more smoothly and wear longer. A good wrinkle relaxer coupled with a smoothing primer can mimic the effects of Botox.

Primers to try:
Maybelline Instant Age Rewind Primer, $8.49
Ramy Elixir Skin Conditioning Primer, $40
Smashbox Photo Finish Foundation Primer, $36

CONCEAL

Before applying concealer, step back from the mirror and look at your face objectively. Think in terms of light and depth. Where on your face is there unwanted depth in the form of a line, wrinkle, or loss of volume? You want to add light to those areas so that they are less deep and visible. Apply a concealer that is a shade or two lighter than your complexion directly to the center of the line or wrinkle and blend out. The objective is to visually eliminate the depth. Applying concealer this way can often make the issue completely invisible. It's a great trick for postponing

Botox and fillers or prolonging their effects and creating a more youthful appearance.

Apply a moisturizing concealer around the entire orb of eyes, from lash line to brow bone and under the eyes. Blend well. Add concealer where needed on your face: on any blemish or discoloration. Add a touch of concealer onto any lines and wrinkles, directly on top of where you applied wrinkle relaxing cream, and blend. A great trick is to also draw the concealer directly onto your labial folds and any lines on your forehead if they are deep, and blend. The concealer will lighten the line and visually decrease the depth of these areas, creating a smoother-looking complexion.

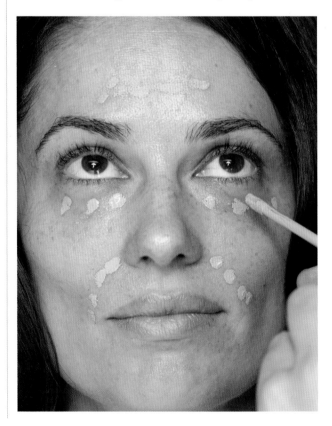

Reveal

Add a tinted moisturizer or BB or CC cream where needed on your face instead of foundation. The moisture and subtle tint of color will create a natural, yet more youthful complexion. The other nice quality of these creams is that they are sheer enough so that each one flatters a wide spectrum of different complexions, meaning you can choose from light, medium, or dark and the BB/CC cream will most likely be a good match for your complexion. If you need more coverage than a BB or CC cream offers, you have two other options:

1. Apply the BB/CC cream as you would any moisturizer. Apply a moist concealer anywhere you need extra coverage. Blend well. Set with a light pat of translucent powder.

2. Apply a moisturizing foundation. Don't apply the foundation all over your face as you would a tinted moisturizer. Instead, apply the foundation with a light hand, focusing more foundation on those areas that need the coverage. Add a light dusting of pressed powder to set the foundation. Your objective when applying foundation should not be to cover up, but rather to enhance and perfect.

Test to choose the correct foundation color for your skin, by applying a swatch of the foundation in a line from your cheek down to your jawline. Blend it in slightly and wait a minute for it to dry. If you can see the streak of foundation on your skin, it's the wrong color for you. The correct color will be undetectable. The wrong color will show up because it is too light, too dark, too yellow, too pink, and so on.

Buff

Whether you are applying just concealer, a touch of foundation or concealer, or foundation and powder, you want to blend the makeup and remove any excess product by buffing. To buff, you take a cotton ball, cotton round, or makeup sponge and gently tap over the concealer, foundation, and/or powder in light, circular motions. This will further blend your makeup and remove the excess, which you'll see on the cotton ball after you buff. The excess that buffing will remove is the product that also sometimes gets into the lines and pores of your skin, aging your appearance. Buffing keeps your "canvas" looking fresh and real. It's one of the most important (and neglected) steps in a proper makeup application. Many beauty pros like to use a dampened sponge to buff the areas where makeup tends to crease on your face. I find this works well if your skin tends

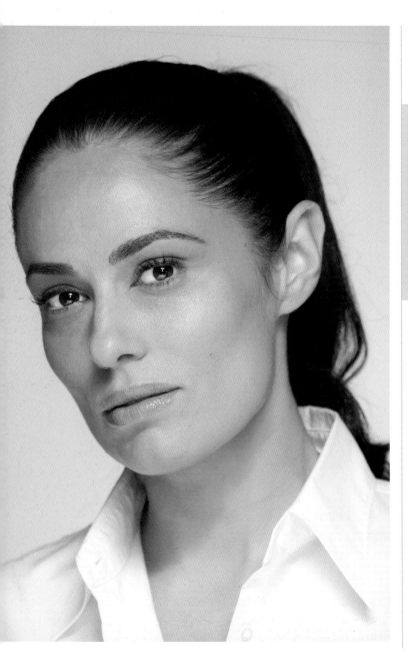

to be dry, but just be careful not to buff away too much of your makeup! A dry sponge or cotton ball offers a bit more control because it requires more buffing to remove and blend your makeup.

RAMY PRO TIP: Lightly colored powders can be very corrective and also impart a youthful glow to your complexion while diminishing the appearance of fine lines and imperfections. Apply tinted powder lightly to set concealer, tinted moisturizer, or foundation. Pressed or loose powder will work, but apply with a light hand and blend well. Choose the following, based on your skin tone: pale skin: pale pink powder; medium and tan skin: pale yellow; dark skin: orange or terra-cotta.

BB and CC creams to try:
Garnier Skin Renew Miracle Skin Perfector BB Cream,
* $12.99*
Ramy Sleep in Beauty, $48
Giorgio Armani Luminessence CC Cream, $50

Foundations to try:
Revlon Age Defying Firming + Lifting Makeup, $14.99
Ramy Elixir Liqui-Powder Foundation, $39
Kevyn Aucoin The Liquid Airbrush Foundation, $45

Tinted powders to try:
Ben Nye Luxury Powder in Banana, Pretty Pink,
* or Topaz (Dark) $8 to $20*
Bobbi Brown Retouching Powder in Yellow, Pink,
* or Brown $36*

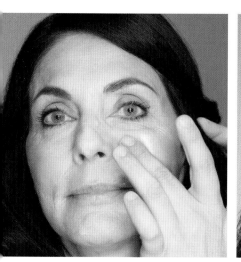
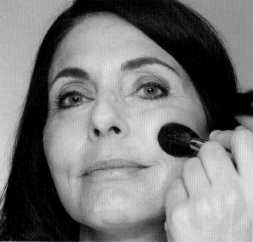
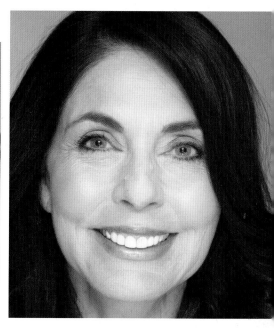

My Youth Recipe Blush

Apply a nude blush along your cheekbones and hairline, then add a cream white highlighter high up on your cheekbones. Blend the highlighter until it's a colorless light reflector. The highlighter not only plays up your cheekbones, but also adds a youthful dewiness to your complexion. Once the highlighter is blended in, smile and apply a pale pink blush just to the apples of your cheeks. The pink powder blush will blend away any line of demarcation the cream highlighter may have left behind. The combination will give you a youthful glow and natural flush of color.

This "Youth Glow Combo" can be achieved with cream blushes as well. The key is the universally flattering mix of nude/apricot and pale pink blush combined with highlighter. This color combination works beautifully on pale, medium, or olive (tan) skin tones. For darker complexions, switch out the nude for a plum or burgundy shade of blush and opt for rose or mauve blush. (Pale pink can work on dark skin as well, depending on the skin tone.) The white highlighter is universally flattering and will look amazing on all complexions.

Blushes to try:
CoverGirl Classic Color Blush in Rose Silk, $5.49
Ramy Blush in Alive! and B.Slapped!, $19
Ramy Pure Juice Highlighter, $28
Laura Geller Baked Monochromatic Blush in Maui, $27.50

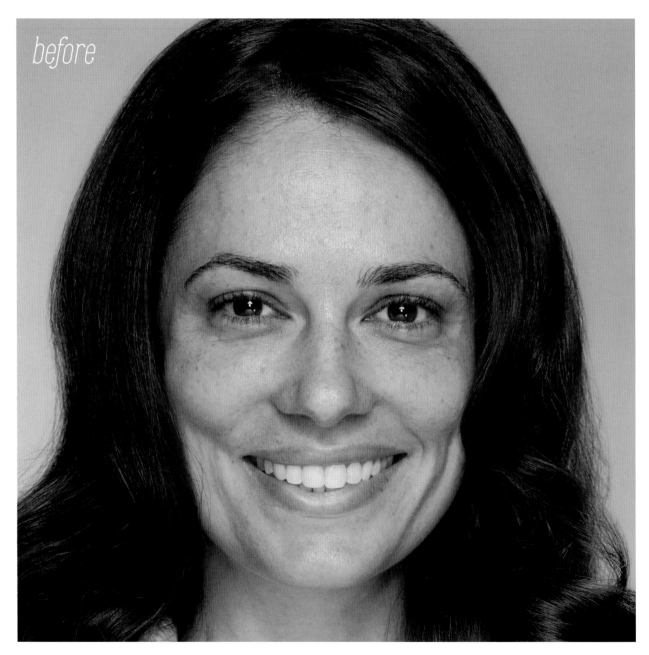

before

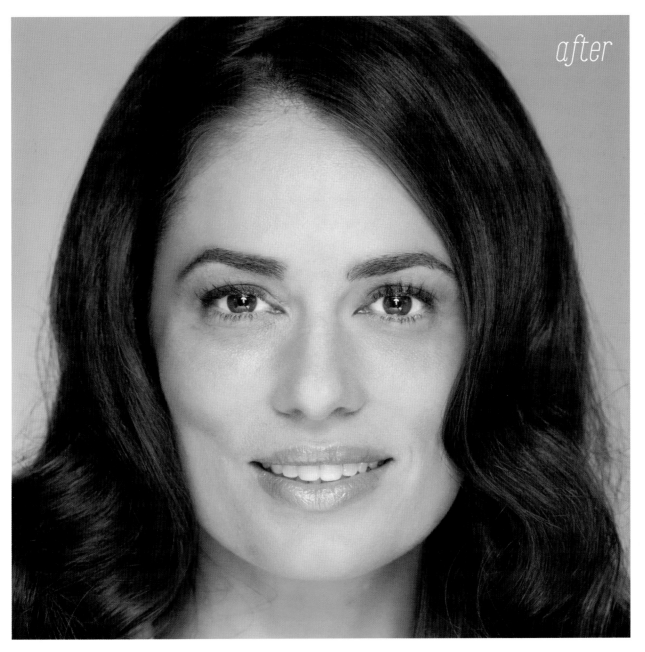

after

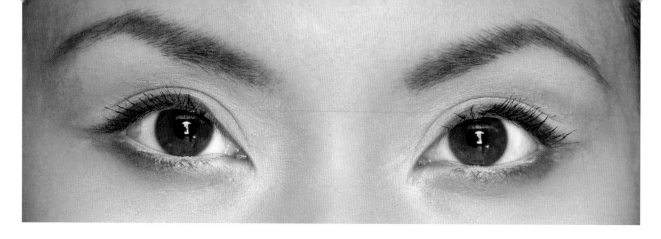

Faking Younger Eyes with Makeup

To look younger, your makeup should be strategic and effective. Once you've created a youthful canvas with the steps outlined already, it's time to define and lift your eyes. Once you have applied concealer around the entire orb of your eyes and set it with a little translucent powder, you have the option to apply a light, matte eye shadow from lash line to brow bone as your base color. A pale yellow, flesh tone, or white color looks best. Your concealer and powder act as a base color already, so if you're a minimalist, you can skip the pale base shadow.

Add a taupe or gray eye shadow to the outer crease of your eyes, where you can feel the edge of your eyeballs. Blend the shadow back and forth. If you're using a powder eye shadow, apply it to your crease using the narrow tip of your eye shadow brush. If you're using a cream shadow, you can apply using your finger tip, but a brush will give you more control over where you apply the shadow. If you use a pen or pencil shadow formula, simply draw onto your crease and blend back and forth with your finger tip.

Add eyeliner to the upper lash line, as close to the lash line as possible. Smudging the line will help hide imperfect applications and also create a softer effect. While you can use an eyeliner in the color of your choice, I advocate a mahogany or brown/black shade if your objective is to create a more defined eye and not look made-up. This neutral shade will do the job without drawing attention to itself. Add mascara in black or dark brown to the upper lash line only.

PRO TIP: Beauty writer Mary Rose Almasi says, "Waterproof eyeliner is a game changer in your forties because it stays in place—you don't look in the mirror at the end of the workday and see a faded version of who you were that morning. It matters—we've got to take steps to not look harried as we age. You need definition on your eyes, and this is an easy way to look fresh and youthful."

RAMY PRO TIP: Oily eyelids help prevent premature aging but can also cause eye makeup to slide off or smear. If your eyelids are excessively oily, wash your eyelids once a week with mild baby shampoo. You'll find that your eye makeup will wear longer.

BASIC RULES FOR AGING EYES

- Stick to softer, matte colors when choosing eye shadows.

- Switch from black eyeliner to brown/black, mahogany, or dark plum, which have just as much impact as black, but look softer and more youthful.

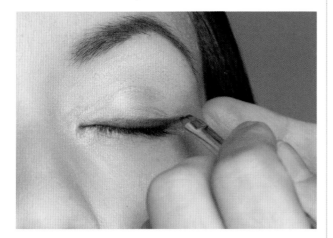

- A moist concealer is like a time machine. Many people who have lines around their eyes opt not to use concealer because they think it emphasizes the lines. That's not true. What happens is that they (or I) apply the concealer and then they hold the mirror as close as humanly possible to their face and they start overfocusing on the lines. I'll apply the concealer on one eye and let the client see the dramatic difference between her two eyes. One will have dark circles, redness, sunken-in eyes, while the other will look bright, lifted, uniform in color, but she will just zoom in on the fine lines and not see that the eye with concealer looks at least ten years younger.

- If you have drooping skin above your eyelid and surgery is not an option, fake an eye lift by drawing a neutral shadow onto the crease of your eye, blending it upward onto the offending area. Choose a putty/gray/taupe color that mimics the color of shadow, as in "light and shadow." The shadow will create depth and fake a crease, giving your eye a defined, youthful look of an eye lift.

- Whenever the subject of undereye bags comes up, I'm asked about hemorrhoid cream. It's practically an urban myth that the active ingredient used in these ointments to shrink hemorrhoids is also effective to help tighten and shrink bags under the eyes. I say don't make an ass of yourself! While some makeup artists swear it works when they mix hemorrhoid ointment with an eye cream, I think the tightening effect you might feel is simply from having the cream on your eyes. A better option to achieve this tightening effect is aloe vera gel. The active ingredient in hemorrhoid cream helps to shrink blood vessels, so it won't do much to help undereye bags.

 A real solution is to cut back on salt and alcohol and to apply a chilled cucumber or potato slice on your eyes. Keep aloe vera gel in the refrigerator or fill an ice cube tray with the aloe vera gel and freeze it. Then use the "aloe cubes" as a cold compress on your eyes. It feels great and will really make a difference in the appearance of under-eye bags. You can also apply the aloe cubes on your eyes the night before as a preventative measure.

- To make undereye bags less noticeable, apply a matte nude blush or bronzer to cheeks and then, still using a blush or bronzer brush, sweep the blush or bronzer directly onto your undereye bags.

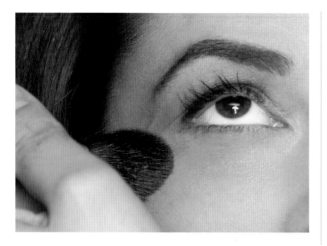

- Brighten strategically. Applying a shimmery eye shadow to areas where you have lines or wrinkles will only play up those areas. However, you can and still should apply a light-reflecting highlighter to the inner corners (tear ducts) of your eyes. Blend well so that you don't see the highlighter per se, but are left with the light-reflective quality. Choose a colorless (white) highlighter or pale pink, peach, or flesh-tone shade for a subtle effect.

Matte eye shadows to try:
MAC Cosmetics in Satin Taupe and Blanc Type, $15
Ramy Cosmetics in Neutral Impact! and Golden Glow, $17
Chanel Ombre Essentielle in Lily and Slate, $29.50

A Youthful Brow

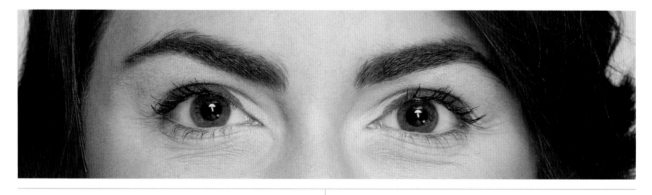

A good brow shaping can take years off of your appearance (see chapter four). Do not underestimate the power of a good brow shaping. Many clients tell me I save them a fortune on injectables and surgery simply by visually lift-ing their eyes with a great brow shaping. If your eyebrows are naturally skimpy, fill them in. Filling in your eyebrows can make even substantial eyebrows look better. A denser brow is more youthful and adds definition to the eyes and

the entire face. Use brow filler that is two shades lighter than your hair color (two shades darker if you're blonde or silver). Apply to the entire brow in small strokes and then (very important) take a small brush and brush the product through your brows. This removes the excess and blends what's left behind for a natural finish. Whether your eyebrows are perfect or "underestimated," filling in your eyebrows will make them appear more dense and plush. This density and an eyebrow that fully frames your eyes will enhance your look for a more youthful appearance.

Youthful Lips

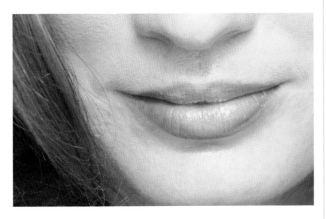

Old lips are thin and dry. Young lips are moist, plump, and fuller—but that's not all: they are surrounded by smoother skin. If you have lines or wrinkles surrounding your lips (something many cigarette smokers have to contend with), then you want to smooth the skin around the lips. Prescription-strength Retin-A can help diminish the appearance of these lines and wrinkles, as will applying a wrinkle relaxing cream before applying your makeup. Add a silicone-based primer on top of the wrinkle relaxing cream. The primer will lock the wrinkle filler in place and create a smoother surface, preventing lip color from bleeding into the lines. If you suffer from lipstick color bleeding into lines surrounding your lips, use a lip pencil to outline your lips before and after applying lipstick to further create a barrier that prevents bleeding.

Your Most Youthful Lip Colors

As a rule, lighter and brighter lip shades look more youthful. That said, lipstick colors look different on each individual. You might read in a magazine that bright red lips are aging and then see it looking fabulous on someone. The key with lipsticks is trial and error. Find the shade that doesn't look washed out or too bright or dark. A great trick is to apply a bright, sheer gloss on top of your lipstick. Lip gloss is moist and sheer, so adding it to your lipstick will add brightness and moisture that imparts a youthful finish.

FAKING **BIG,**
BEAUTIFUL EYES

Meet Our Model >

I chose DARIN for this chapter because her eyes are already beautiful and I wanted to demonstrate how even the loveliest eyes can look bigger, brighter, and more glam in a few simple steps.

Ninety-nine times out of one hundred, when I'm doing someone's makeup they tell me that they want to play up their eyes. Oftentimes, when people want to play up their eyes they overdo the makeup—too much eye shadow, tons of eyeliner, or false lashes that are too big—end up making the eyes look smaller, or make it difficult to see the eyes altogether. The correct makeup technique to make your eyes look as big as possible is simple: the objective is to define your eye shape and enlarge the appearance of your eyes by strategically applying your makeup. When I do a makeup application, the most steps that go into creating a face are on the eyes.

10 Steps to Your Very Best Eyes

STEP ❶: Apply eye drops ten to fifteen minutes before starting your makeup to whiten the whites of your eyes and brighten their overall appearance. Blue eyedrops not only counteract red eyes, but also really make the whites of your eyes look super white.

STEP ❷: If you need to curl your eyelashes, do it now, before applying makeup. Hold the eyelash curler as close to the roots of your lashes as possible and squeeze gently but firmly.

STEP ❸: Apply a concealer around the entire orb of your eyes, both below your eyes as well as from your lash line to your brow bone and entirely around your eyes so that the concealer is on the darkest point (by your tear ducts). This acts as a primer for your eye makeup and brings the entire eye forward, concealing redness and discolorations and giving your eyes an even and lifted appearance.

STEP ❹: Set the concealer with a touch of pressed powder. The powder makes the concealer stay put and gives the eye shadow something to adhere to so that your makeup will last.

STEP ❺: Apply the eyeliner to your upper lash line. Begin the line at the base of your lashes where the eyelashes begin by your inner eye. The line should start out fine, getting thicker as it goes across your lash line, and then narrow to a fine point at the outer end. If you have large eyelids, you can make the line thicker; if you have small eyelids, keep the line thin. You can

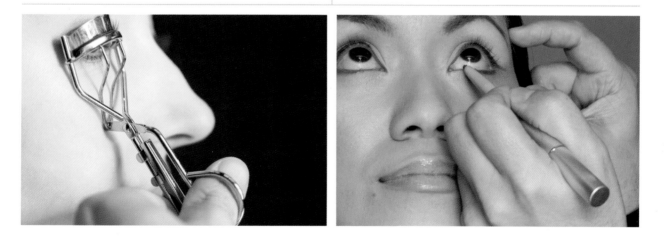

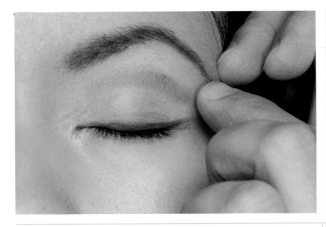

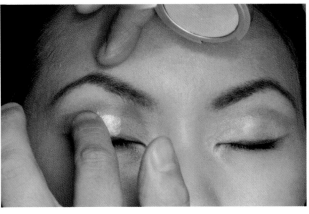

extend the line slightly past your outer eye to lift and open your eyes more, but you can also end the line where your eyelashes end. If you do extend past your outer eye, there is no need to wing the line by angling it upward as it passes your outer eye. Your eye structure will create the wing for you.

STEP 6 : Adding heavy eyeliner to your lower lash line will close up your eyes and make them look tiny. That said, applying liner to your lower lash line with a very light hand can define and make your eyes look even bigger. Apply the same shade of liner you used on your upper lash line directly onto your lower lashes, beginning the line where your eyelashes begin on your inner eye and ending where your eyelashes end at your outer eye. This line should be very fine, appearing to simply deepen your lash line. The liner on your upper eye should be far more dramatic and still remain the focal point.

An old makeup trick is applying a white eyeliner to the inner rim of your lower lash line to extend the whites of your eyes, giving your eyes a bigger, brighter appearance. If you do this, be sure to blend the liner well so that the white is not too stark, or the effect

can make you look wild-eyed. A safer option is to choose an eyeliner that's peach or flesh-toned. I used a white pencil on the model here, and it did the trick without really being noticeable. That's how you wear white liner in the rim of your lower lash line. It should be nearly imperceptible but extend the whites of your eyes, giving them a larger appearance.

STEP 7 : Apply a neutral (taupe, brown, gray) eye shadow to the outer crease of your eyes and blend it back and forth. This will define the shape of your eyes without creating a made-up look. Choose a neutral that mimics the look of shadow, as in "light and shadow."

STEP 8 : Add a light-colored eye shadow or cream highlighter to your tear ducts and across your eyelid. Choose white, gold, peach, or pale pink shades. If you have heavy or large eyelids, opt for a deeper shade.

STEP 9 : Apply mascara to your upper lashes. Add as many coats as desired, but no matter how many coats of mascara you add, be sure to add an extra one to your outer lashes. If you truly want your eyes to look their biggest,

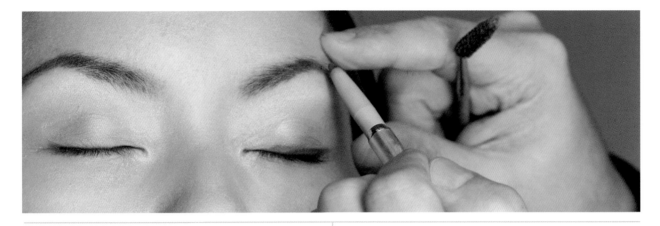

forego applying mascara to your lower lashes. This is a huge adjustment if you're used to wearing mascara on your lower lashes, but the liner is sufficient to define your eyes. The liner and mascara on your upper lashes only will make your eyes appear their biggest. Eliminating mascara on your lower lashes also solves most of the complaints I hear about mascara, like running and smudging.

STEP 10 : Fill in your eyebrows even if your eyebrows look fine to you already. Adding an eyebrow filler in the appropriate shade (see page 46) adds a bolder frame to your eyes. You can also extend your brows slightly to bring them closer together if they're too far apart or extend the outer ends if they are too short, thus more fully framing your eyes and making your eyes appear larger.

Eye drops to try:
Visine Eye Drops, $1.99 to $7.99
Collyre Bleu Laiter Eye Drops, $39.99
Innoxa Gouttes Bleues (French Blue Eye Drops), $14.99

Eyeliners to try:
L'Oréal Infallible Never Fail Eyeliner, $8.99
Ramy Perfect Eye Wand, $24
Nars Eyeliner Stylo, $27

RAMY PRO TIP: A great trick if you have tired eyelids is to apply eyeliner on the water line of your upper lash line. Make sure you're using a pen or pencil that is formulated for this so it won't run and/or irritate your eyes. The lift to your eyes will be palpable. Full disclosure: as a makeup artist, I rarely apply eyeliner this way on a client, because it's a rare woman who won't mind a sharp implement being directed at her inner eyelid. A good alternative that offers slightly less lift, but just as much impact is to apply another formula of eyeliner directly on top of the eyeliner on your upper lash line. For example, if the eyeliner you apply is a pen or pencil formula, apply a powder or cake formula on top of it with a moistened eyeliner brush. This adds dimension and intensifies your eyeliner, making it more dramatic. It will also help your liner last longer.

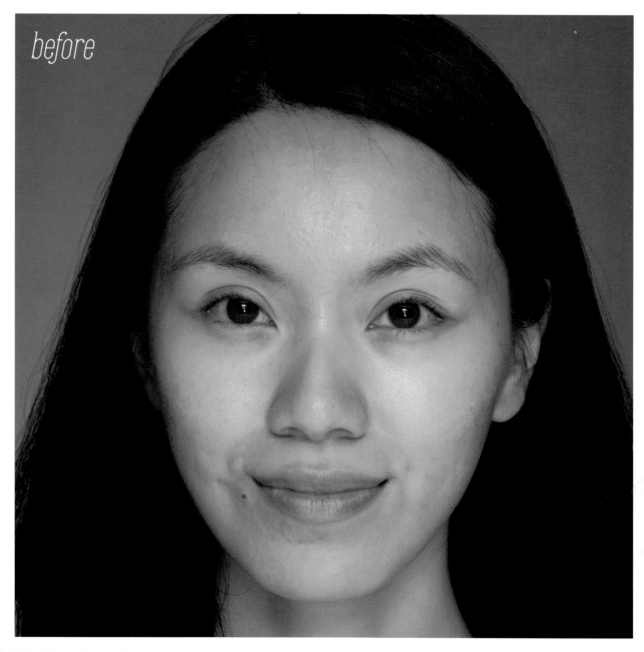

before

after

Line Up for Great Eyes . . .

Close-set: Begin with a fine line from the center of your upper lash line, and extend it to just past your outer eye, making the line thicker as it progresses toward your outer eye. Line your lower lash line also; from the center of your lower lash line, extend the line to where your lash line ends by your outer eye. This will visually draw your eyes farther apart by drawing the focus to your outer eyes.

Wide-set: Begin the liner on your upper lash line at your tear duct, ending where your lash line ends by your outer eye. Line your lower lash line also, beginning at your tear duct and ending where your lower lashes end by your outer eye. Keep the line uniform in thickness from beginning to end.

Small: Line your upper lash line only, extending the line past your outer eye. Apply white or flesh-toned liner to the inner rim of your lower lash line to extend the whites of your eyes, giving your eyes a larger appearance.

Too big: Follow the rule for wide-set eyes, then add liner to the inner rim of your upper and lower lash lines. A thicker line will make large eyelids look smaller.

In need of a lift: Apply liner to your upper lash line, starting with a narrow line on your inner eye, gradually thickening the line as it extends toward your outer eye. Then continue the line past your eye (think cat-eye). There's no need to curve the line as it extends past your outer eye; simply continue the line in a straight line along your eyeline. However, if you do angle the liner upward as it extends past your outer eye, the winged eyeliner not only is very glamorous, but also adds more visual lift to your eyes.

Optional: Add liner to your lower lash line with a very light hand to add definition to your eyes instead of using mascara on your lower lash line, which visually will pull your eyes downward.

PRO TIP: **Amy Keller Laird, Editor-in-Chief at *Women's Health* magazine, says, "The one thing that adds awesome definition to eyes with the least amount of time (or skill) is to trace a smudgy jet-black eye pencil along the inner lower rims, then repeat right along the lash line. Even if you're not wearing shadow or lipstick, you still look pulled-together."**

The Dos and Don'ts for Big, Beautiful Eyes

Keep it clean: Your eye makeup should look uncluttered. People should notice your eyes, not your eye makeup.

Lighten up: Use light colors to bring an area forward and make it look bigger; use darker shades to create depth.

Shimmer up: Light-reflective colors can enhance and brighten.

Do some testing: Figure out which style (technique, formula) of eyeliner works best for your eye shape.

Lash out: Long, separated lashes enlarge the look of your eyes. Overly dense, heavy lashes can make your eyes look smaller.

Perfect your brows: Make sure your eyebrows fully frame your entire eye area. The eyebrows should not be too far apart or too short on the back end.

Use the color wheel: To intensify your eye color, choose eye shadows and eyeliners in colors that are at the opposite end of the color spectrum from your eye color. If your eyes are blue, opt for earth tones like browns, bronze, and copper. The contrast will make your blue eyes pop. If your eyes are green or hazel, earth tones will work, too, but shades in the plum family will intensify the green in your eyes. Brown

or black eyes look their best with grays, purple, or lavender shades, or even blue-based colors. When in doubt, neutrals like taupe work well on everyone, but if you want to intensify your eye color, look at the color spectrum wheel and choose colors that are on the opposite side of the wheel from your eye color.

PRO TIP: *Good Housekeeping's* Beauty Director April Franzino says, "Brighten your eyes. I never leave the house without dotting a light shimmer eye shadow or highlighter on the inner corners of my eyes (I choose a champagne hue for my olive skin)—literally two seconds and you instantly look awake."

Care and Maintenance for Youthful Eyes

The delicate skin around the eye area is the thinnest on the body, second only to our lips. For many people, the first signs of aging begin at their eyes: drooping skin above the eyelids, bags below the eyes, smile lines and wrinkles at the outer corners. Counteracting these tell-tale signs of age and applying the correct colors and formulas of makeup will alleviate these "cracks in the armor" and keep you looking youthful for decades to come.

Stay Moisturized

Do not underestimate the power of a good eye moisturizer. Applying an eye cream will soften the appearance of fine lines and help prevent lines from getting worse. Eye moisturizers do differ from facial moisturizers. They are formulated specifically for the eye area and often offer more intense moisture.

It's not just about moisture anymore, though. It's also about firmness. Ingredients like hyaluronic acid (often listed as glucosamine, glycosaminoglycan, Halloran, or hyaluronic) can help plump the areas around the eyes that have lost volume. Vitamin A can diminish lines and wrinkles, and vitamin C can increase brightness. Granted, the percentage of active ingredients is not as high as prescription strength, but they can still improve the feel and appearance of your eyes. Remember to apply any eye treatment around your entire eye, not just under your eyes.

PRO TIP: Beauty writer Mary Rose Almasi says, "To see if your undereye circles are from the veins under your eyes showing through (which requires concealer) or discolored skin (which is from a buildup of pigment) look in the mirror. With a finger, gently drag your undereye skin downward past the lower eye socket. If the dark color travels with the skin, it's trapped pigment. There are good eye creams made to break up the pigment. Look for those in particular."

Prescription-Strength Solutions

Prescription-strength Retin-A (vitamin A) can work wonders on your entire face, including the skin around your eyes, by diminishing fine lines as well as increasing volume and collagen production, thereby decreasing the appearance of dark circles. Speak to your dermatologist to decide on the correct formula and prescription strength for you. Most doctors will suggest starting with the lightest prescription to begin with, as many people experience skin irritation and redness, particularly if you have fair or sensitive skin.

How to Fake Luscious Lashes

As we age, our eyelashes sometimes get shorter, more sparse, and skimpier. Some of us were never blessed with glamour-girl lashes to begin with, but there are a lot of things that can help!

Makeup Solution

Adding soft (brown/black) eyeliner along your upper lash line, as close to the roots of your eyelashes as you can get, will fill in your lash line to create the look of fuller eyelashes.

Apply a brown/black liner to your upper lash line only. The line should begin where your eyelashes start and extend just past your outer eye. Smudging the liner enhances the illusion of plusher eyelashes, whereas a hard line can work, too, but will create a more made-up look.

Then add mascara to your upper lash line only. Add an extra coat of mascara for every decade over thirty: one extra coat if you're forty, two extra coats if fifty, and so on. A great mascara can work wonders and might be all you need. There are also great products to apply under mascara to prime your lashes, as well as products to apply on top of mascara to further extend, thicken, and lengthen your lashes. (Ramy Triumph! Mascara Revitalizer is one!)

Mascaras to try:
Maybelline Illegal Length Fiber Extensions Mascara, $8.95
Ramy One Stop Shopping! Mascara, $19
Dior Addict It-Lash Mascara, $26

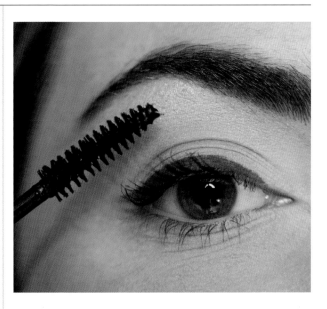

PRESCRIPTION SOLUTION

Latisse really works to help lashes grow and get really long. The downside is that if you have light-colored eyes, there is the risk of developing a dark spot in your iris that will be permanent, even if you stop using the Latisse. Some people also develop a dark line along the lash line where the product is applied, but that will disappear once you stop using the product. While it works magnificently, Latisse is pricey, and the long-lash effects disappear when you discontinue using the product.

Conditioning Lash Serums

Applying natural oils—castor, coconut, olive, almond, or vitamin E—each night before going to bed will coat and moisturize your eyelashes, as well as give them a protective coat to help prevent damage.

Apply a small drop of oil along the roots of your eyelashes, using your fingertip to blend it in. Use a cotton swab to apply if the oil is not in a dropper container. Blot any excess oil with a tissue. I've especially seen dramatic results with vitamin E oil (70,000 iu) and castor oil. At the very least, applying an oil to your lashes periodically will help keep them moist and conditioned. When your lashes are in good condition, they are less likely to break.

Growth Serums

There are many commercial brands to choose from. Look at the ingredient list to help find one that works best for you. Like natural remedies, commercial-brand growth serums will at the very least condition your eyelashes to encourage more growth and less lash loss. Some, like my Eye Grow Brows! Serum, also coat the existing lashes to give an instant thickening and lengthening effect.

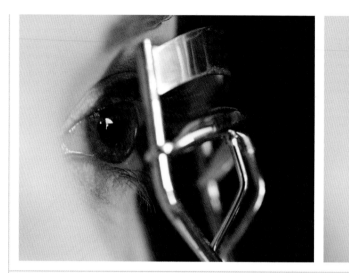

Curl Up

If your eyes are the windows to your soul, then your eyelashes are the shutters to those windows. You want to ensure that the shutters are open all the way so that your eyes look their very best. Curling your lashes with an eyelash curler keeps your lashes going in the right direction and gives your eyes a bigger, more awake appearance.

Curl your eyelashes before applying any mascara by holding the curler as close to the roots of your eyelashes as possible. Squeeze the curler shut firmly, but not so tight that you risk pulling out your eyelashes. Hold the curler in the shut position on your eyelashes for a few seconds. Often when I'm applying makeup, I find that the eyelashes are already going in the right direction and don't really require curling, but if your eyelashes go in a downward direction, an eyelash curler can make a world of difference.

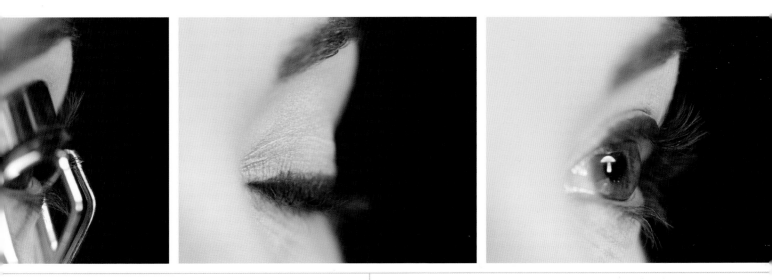

The idea that heat will help curl the lashes better arises periodically. Self-heating lash curlers pop up on the market. I don't recommend them. I've never seen a heated eyelash curler make a bit of difference from a standard lash curler. Here's a tip, though: while a heated eyelash curler won't enhance the curl, washing your face with warm water just prior to curling your lashes will help your lashes hold the curl longer.

DYEING OR TINTING

Dyeing your lashes can make a dramatic difference, especially if you have blonde or light-colored eyelashes. While dyeing will not lengthen and thicken your lashes the way mascara will, it will make them more visible, and if you're blonde, it can last up to two weeks. If you have naturally dark lashes, tinting will also enhance them, but it lasts just a few days.

Lash Extensions

Lash extensions are a more lasting solution for faking fab lashes. They need to be applied by a professional and last anywhere from two to four weeks. The extensions are painstakingly glued to your own eyelashes and often require touch-ups at the salon after a couple of weeks, as some of the lashes begin to fall out.

Like hair extensions, lash extensions come in a variety of styles, and the results vary depending on how experienced the pro is at applying them.

Lash extensions are great for special occasions and if you don't enjoy applying mascara every day. However, I suggest taking breaks between lash extension applications—one month on, one month off—because keeping the extensions on without a break can result in losing your own eyelashes.

Supplements

Healthy hair growth, whether it's the hair on your head or your eyebrows and eyelashes, requires good nutrition. Even if you have a well-rounded diet, it's a good idea to take a multivitamin daily with a meal. This will ensure that your body is getting all the nutrients it needs to help boost hair growth.

There are additional supplements you can take that are formulated for hair and nail growth that usually contain extra biotin and zinc. These ingredients are known to help hair growth.

I've seen results from taking a good multivitamin daily along with additional biotin and zinc supplements. I've seen great results from taking prenatal vitamins, too. Like skin care, the key to optimum results with supplements and vitamins is consistent use. Taking them once a month or sporadically will limit the results, so make it part of your daily routine, and you should see a real difference.

Exfoliate and Massage

Another aspect that can improve eyelash (and eyebrow) growth is to make sure the area is exfoliated so that the hair follicles are not blocked by dead skin cells. Many commercial lash enhancers contain exfoliating ingredients that work well when applied along the roots of your eyelashes. If the product has a warning that it may cause redness or irritation, it most likely has an exfoliating ingredient. Also look for any acid on the ingredient list, like hyaluronic acid, which acts as an exfoliator.

Gently massaging your eyebrows or eyelashes, with your fingertips or a small brush will boost blood circulation to the area and help stimulate growth. Massaging these areas for just a few seconds when washing your face will do the trick.

How to Use False Eyelashes

False eyelashes can add instant glamour and a more dramatic lash line to any look. When I did Britney Spears's makeup, she didn't look like "Britney!" until I applied a full row of lashes. Suddenly she looked like the famous face we all know. False lashes are great for special occasions or a night out, but I don't recommend them for daily use. Continuous use of the adhesive on your lash line can hinder lash growth over time. Plus, there are so many great solutions to create fabulous eyelashes without the hassle of applying false eyelashes 24/7.

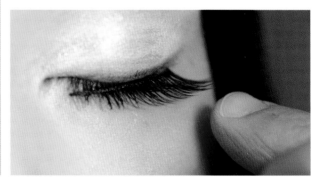

Basic Rules for Applying Lashes

- If you're going to curl your eyelashes, do so before applying mascara or lashes.

- Invest in a separate bottle of adhesive. Don't rely on the adhesive packaged with the lashes, as they aren't always the best, and if you mess up, there may not be enough adhesive left to get the job done.

- Apply the mascara and eyeliner to your upper lash line before applying the lashes. The eyeliner also acts as a template to make it easier to apply the lashes as close to the base of your lash line as possible.

INDIVIDUAL LASHES

- Adding two or three individual lashes to the outer corner of your upper lash line will dramatically glamorize your eyes. Individual lashes can also be used to emphasize different qualities of your eyes. For example, adding lashes on the outer end not only results in a glam look, but also will make your eye appear longer. Adding more individual lashes to the center of your eyelid will make your eyes appear rounder.

- Using tweezers to hold the individual lash, apply adhesive to the "root" of the lash and give it a moment to dry slightly. The tweezers offer precision and control. With the tweezers, apply the lash as close to the base of your outer lash line as possible.

- Repeat with as many individual lashes as desired. I find that three to five individual lashes are usually ideal.

FULL-ROW FALSE LASHES

There are many styles to choose from, from "Drag Queen Fabulous" to ultra-natural. Choose a style that suits you. I used Kevyn Aucoin's Lash Collection in the Starlet ($25) on the model in this chapter's opening photo. I love it because the outer lashes are more dramatic than the inner lashes, and so it mimics the look of adding individual lashes to the outer eye, but is much easier to apply.

- Once you are ready to apply, check the size of the row by applying it without any adhesive to your lash line, starting from the outer lash working your way toward the inner lash. If it's a good fit, you're ready to apply it.

- If it's too long, cut it using small brow or safety scissors. It's usually a better idea to cut the outer, longer part of the row, not the shorter part that lands by the inner eye.

- Once sized and trimmed, add the adhesive. Apply the adhesive to a cotton swab and then run the cotton swab along the base of the lashes. Place the lash as close to the roots of your lash line as you can. A good fit will not poke you in the eye and will lie flush against your own eyelashes.

- Apply more mascara to meld the false lashes and your own lashes together.

- Optional: Add more eyeliner if you need to perfect the line or want a more intense eyeliner look.

False lashes to try:
Ardell Individual and Full Row Lashes, $3.99
Make Up For Ever Individual Lashes, $16

chapter four _____

HOW TO FAKE
ENVIABLE
EYEBROWS

Meet Our Model >

KATELYN's sister, Jen, was a client of mine first. Jen brought Katelyn for her first brow shaping with me when Katelyn was just twelve years old. Ten years later I'm still the only person who has ever touched her eyebrows, and I've always told her that if I write a book, she will be my brow model. Their father, Joseph Mascali is an American hero. He was a firefighter at Rescue 5 in Staten Island who was killed on September 11, 2001, as he tried to save others. I've had the privilege of seeing his daughters grow into thoughtful, lovely young women he would be proud of.

Let me begin by saying that eyebrows are like fingerprints and snowflakes. No two eyebrows are the same, even on the same person. So every rule you hear about eyebrows should be taken with a grain of salt because every rule truly varies depending on the individual. I've been referred to as the "Brow Whisperer" on *Today*, the "Brow Czar" and "Celebrity Wizard of Eyebrows" in the *New York Times*, and the "Christian Dior of Eyebrows" in the French edition of *Elle*. As the pre-eminent "Brow Guru," I've seen it all and can transform any brow into a perfectly beautiful arch.

Only plastic surgery can transform your appearance more dramatically than a proper eyebrow shaping, and sometimes even then the eyebrow shaping will result in a more dramatic transformation. A good brow shaping will make you look more polished. A great brow shaping can lift your eyes, make you look younger or more sophisticated, and essentially turn an "eight" into a "ten."

People always regard eyebrows in terms of thick or thin, but there are many more factors to consider: excess length, sparseness, quality of existing brow hairs, shape of the eyebrow in relation to a person's bone structure, size and spacing of one's eyes, and damage from previous eyebrow shapings, just to name a few things that I take into consideration when shaping someone's brows. In training people to do eyebrows for my brow bars, I've learned that the ability to shape eyebrows well is something that some people are born with and others are not. Someone can be an amazing makeup artist or aesthetician and still not have an eye for brow shaping. When I look at someone the hairs that need to be removed are so obvious it's like they are a different color than the rest of the brow. I always assumed everyone could see it, but now know it's my decidedly unique ability. That said, I've discovered many others who have a good ability for eyebrow shaping, but they're much harder to find than a capable makeup artist, for example. You can teach someone to be a good makeup artist even if they have no talent for it, but someone who has no talent for brow shaping cannot be taught. Add to this fact that it's nearly impossible to be objective when looking at your own face, and you realize why it's so difficult to shape your eyebrows yourself. Of course, you can always maintain your brows between professional brow-shaping appointments by tweezing just the obvious strays to keep your eyebrows presentable without compromising the shape.

Brow Shaping

My most typical response when someone asks me what I think of her eyebrows is, "You have naturally nice brows, but they've been underestimated," which is usually followed by her telling me the traumatic history of her eyebrows, both inflicted by others as well as self-inflicted. However, I'm going to share here for the first time how to shape your eyebrows yourself without underestimating how great they can be.

A person's eyebrows often change during the course of their life. While everything to do with eyebrows is truly individualistic—no two eyebrows are the same, even on the same person, and there are exceptions to every rule—there are some basic truths.

During the teenage years, our eyebrows are their most dense and are also in their natural state until we start to mess with them. During your twenties and early thirties, your eyebrows are at their peak (pun intended). They are their fullest without excessive length or bushiness. From your late thirties through your fifties, hairs can get excessively long; brows become sparser; and your health and lifestyle choices really affect what your eyebrows will look like. From your late fifties and beyond, if you're prone to excessive hair length on your eyebrows, they grow fast and furious, and sometimes just keeping them trimmed will take years off of your appearance.

Many people think that your eyebrows disappear when you are elderly, but I've ascertained that they do not. When you see an elderly woman with no eyebrows, it's either from years of waxing them too thin or from habitually removing "just the white hairs." If you have one or two white hairs (I call them "highlights"), it's okay to pluck them out. The problem occurs as your brow hairs develop many highlights and you keep removing them. You essentially remove your eyebrows altogether. I teach my clients to trim the white hairs so that they are less visible as opposed to plucking them out and risking a gap in your eyebrow.

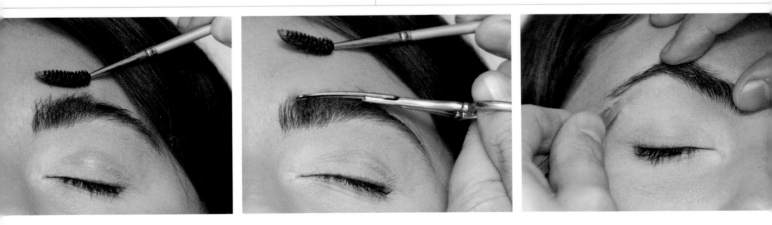

If your eyebrows have been misshaped or overly thinned, either by your own hand or at a salon, the best thing to do is STOP! Go back to square one and let your brows grow back for a minimum of three weeks. If your eyebrows are excessively thin, it can sometimes take three or four months for them to grow in completely. You will be tempted to pluck strays, but the best thing you can do for yourself is to let them grow back as fully as possible.

Usually it is the people who are obsessed with their brows who overdo it and do what I call underestimating your eyebrows. Once your eyebrows have grown in, either go to a brow-shaping professional (if you don't know of one, ask a friend who has fabulous brows—she may have been holding out on you!) or reshape them yourself.

As a rule, I'm personally against waxing the brows—waxing is for cars! Seriously, there is no precision with waxing: you are removing rows of hair indiscriminately, and it is very harsh on the delicate skin around the eye area. And dread the thread! Threading is acceptable if you know an expert who is truly proficient. Threading was the technique of choice in the Middle East, India, and Eastern Europe for many years before tweezers were invented. Today we have indoor plumbing, so why use an outhouse? Therefore, my technique of choice is tweezing and trimming. It offers absolute precision while being delicate on the skin. As for the pain quotient, it all depends on the person who is doing your brows, regardless of the technique.

The key to perfect eyebrows is proportion. An eyebrow should be fully actualized, meaning not too far apart or too close together, not too short or long on the ends, not too thin or too thick, and with an arch that flatters your bone structure. A good eyebrow will be in proportion to your facial features.

When I first started training others to shape eyebrows I really had to review what I know about eyebrow shaping and how to articulate it to others. I developed a few golden rules for brow shaping that ensure that eyebrows will always turn out well.

Ramy's Golden Rules for Eyebrow Shaping

Be conservative: Don't get overly creative. Remove and trim only the very obvious hairs.

Follow nature: Great eyebrows align with your bone structure. The eyebrows you were born with may need to be fine-tuned to achieve a fabulous shape, but they don't need to be completely changed. Keep your eyebrows close to their natural line, meaning don't shave off the back half and draw it in at another angle or make your eyebrows very thin, thereby creating an arch that doesn't follow your bone structure.

Think in terms of straight lines: When removing hairs from below the eyebrow, do it with an eye toward creating a straight line. Even though the line may be at an angle, if you keep it straight, it will always look good. Ninety-nine percent of mistakes in brow shaping occur when the line under the brow is curved into a C shape (the dreaded hook!) or an S shape (the tadpole).

When in doubt, don't pluck it out: One of the most common mistakes when shaping eyebrows is overdoing it. As you're tweezing, if you're not sure whether or not to remove a particular hair, leave it. You can always remove it on another day.

Symmetry: No one has perfectly symmetrical eyebrows. In the beauty industry we say that eyebrows are sisters, not twins. Everyone thinks that the rest of the world has symmetrical eyebrows and that they alone have uneven brows. The truth is, you can shape your brows to help create the illusion of symmetry—and makeup can certainly help further the illusion—but don't overthink it or make yourself crazy trying to achieve symmetry. Usually your eyebrows are following your brow bone structure, and the truth is that the left and right sides of our face are not even. So it goes back to Brow Rule #2: Follow nature.

One of the first celebrities I worked on was almost as famous for having plastic surgery as she was for her film roles. As I was applying her makeup, something seemed off about her face. She was very pretty, but something just didn't feel right about her face. I realized it was that she had her eyebrows perfectly aligned surgically. The left brow was an absolute mirror image of the right brow. It was too perfect, and as a result it didn't look human.

Negative space: What creates your eyebrow is not just the hair you remove, but also the hair that's left behind. If more

brow "experts" thought about this and not just about removing stray hairs, there would be far fewer eyebrow disasters. One of the things I'm most proud of is that I can make a thin, straggly eyebrow look fuller (without makeup) by shaping it strategically. Anyone can make a thick, full brow look better, but you really see the magic when you can make a thin brow look more substantial. It's all about negative space.

Permanent solutions: I'm often asked about tattooing the eyebrows or permanently removing stray brow hairs with a laser. I am opposed to doing anything permanent to the eyebrows because your face changes over time. Your eyebrows change over time, too, and when you make a permanent change, you're stuck with that change forever. Tattoos can change color and require more makeup to look presentable than simply filling in your brows with makeup in the first place. As your face ages, you may end up with eyebrows where you don't want them!

With permanent hair removal, as your brows change over time, getting sparser with age, for example, you'll wish you could grow back those laser-removed hairs, but won't be able to. I've also seen tragic results on the eyebrows with both tattooing (blue eyebrows, anyone?) and laser hair removal. Once it's done, you're stuck. I have seen tattooed eyebrows that have faded and look okay, but it's rare. It usually looks best when you have existing brow hairs and are filling in between the hairs. In areas where you have no hair, the tattoo will look obvious and unnatural. Laser hair removal can be a wonderful solution for other parts of the body where you hope the hair will never grow back, but I've never met anyone who had it done on their eyebrows and didn't regret it.

How to deal with scars: It is surprisingly common for people to have scars on their eyebrows. This usually occurs from childhood accidents—nature wisely makes the brow bone

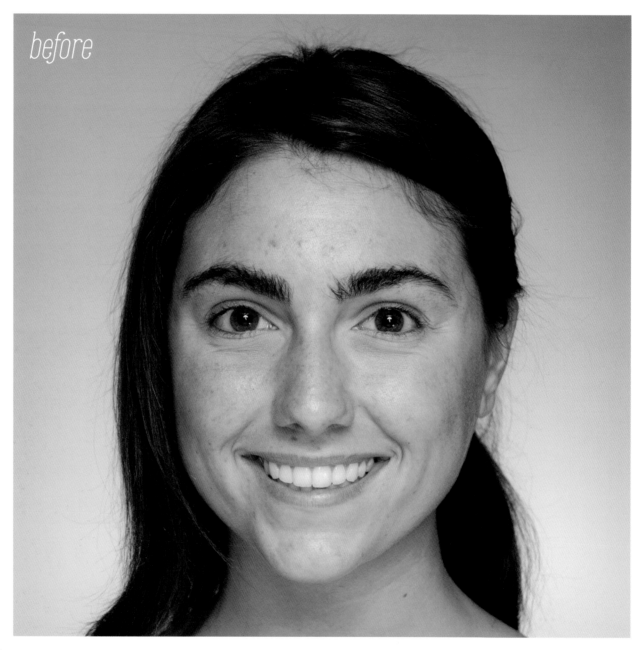

before

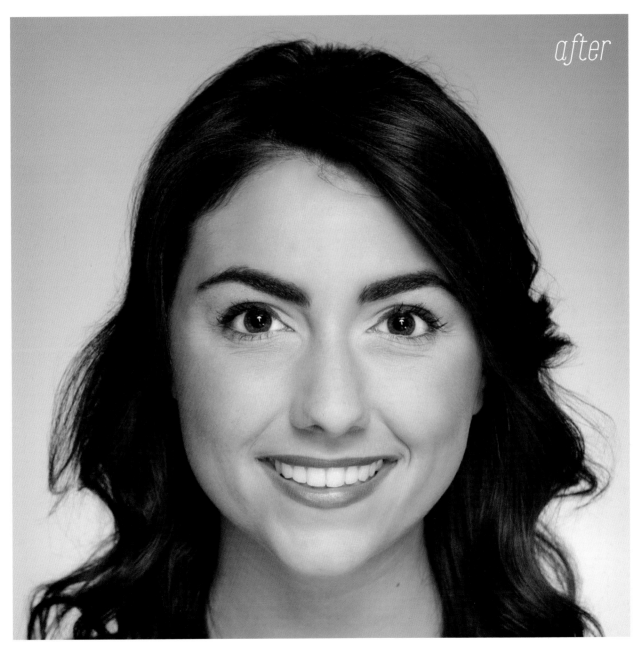

after

protrude so that it protects the eyes. Otherwise there would be many people visually impaired from accidents on the playground! Sometimes scars occur from car accidents or chicken pox, too. My policy is to ignore the scar and shape the brow so that it's ideal for the person's face, as though the scar weren't there. The surprising result is that if you do this, the scar becomes less noticeable. The same holds true for birthmarks that land on your eyebrows.

Shaping your brows to suit your eyeglasses: A common question is how to ideally shape one's brows to flatter their glasses. Like scars or birthmarks, I ignore the glasses and shape the eyebrows to flatter the person's bone structure. If you do this, the eyebrows look their best with glasses on, too. If they don't, it usually means you need new glasses that work with your facial shape.

Using eyebrow stencils: Each eyebrow is unique unto itself in shape, hair pattern, thickness, and length. Because of this fact, I was always opposed to using eyebrow stencils, because they are too cookie-cutter. Usually available in thin, medium, and thick options, there is no way that one stencil will work on both brows, much less on a variety of people with differing bone structure and eyebrows. Year after year, beauty editors and buyers have asked me to produce eye-

brow stencils, and I always refused. I began to think about how to create an eyebrow stencil that is customizable and I created the Brow Master, which is a stencil with movable parts so that you can customize the thickness and length of each eyebrow while making it impossible to create the dreaded hook or curved brow shape we should all avoid.

Stencils can be used as a template to help you fill in your brows if you have no hair on all or part of your eyebrow and need some guidance. The stencil should be used to compliment your bone structure and as a guideline, not a literal template.

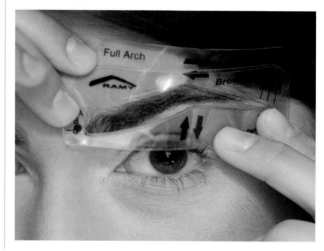

How to Shape Your Eyebrows Yourself

To reshape your eyebrows yourself or maintain a professional shaping you will need several things:

- Large mirror, preferably near a bright window

- Good pair of tweezers

- Grooming scissors

- Small brush (Ramy Browtility Brush, a baby toothbrush, or an old mascara wand that's been cleaned with makeup remover are ideal)

- Lastly, forty minutes set aside so that you don't rush, which often leads to the worst brow fiascos!

My favorite tweezers are, of course, the Ramy Tweezers by Tweezerman. They are not as sharp as many other brands because I designed them to have no point on the tip, but they have a wide tip that's calibrated enough to grab every little microhair! A common mistake is to use pointy tweezers. Pointy tweezers are good for removing splinters, but terrible for shaping your eyebrows. If the tip is a sharp, needlelike point, you are basically shaping your brows with a sharp needle, which will make it difficult to grab hairs and also is far more likely to break the skin and cause bleeding. Choose tweezers with a slanted tip,

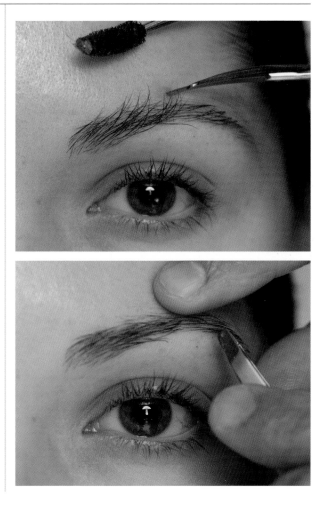

preferably rounded at the point. You will be able to grab any stray hair thanks to the slanted tip and less likely to damage the delicate skin surrounding your eye area.

Always remember that less is more and try to look at your face objectively, using a common-sense approach. I've seen many people stand so close to the mirror that they can't see the forest for the trees. A good test is to stand two to three feet away from the mirror, so that you *don't* see every little hair. Look at your face in its entirety first, and then look at your eyebrows in proportion to the rest of your face. Then move in closer to your reflection and look at your eyebrows and think about where you may need to remove hair. Then, move closer still and begin shaping. I always advise clients that if they are going to maintain their eyebrows at home, pretend there is a line (like a police line!) completely surrounding your eyebrow. Never venture inside that line when tweezing. Remove only those hairs outside of the line so that you are keeping your brows from looking unkempt, but you won't compromise the shape by venturing too close to the eyebrow itself.

STEP ❶: Brush your eyebrows upward. If there is excess length, trim them with the scissors as conservatively as possible—as though you are trimming split ends. The scissors should align with the top of your brows where you want the length to end.

STEP ❷: Tweeze the most obvious stray hairs, those hairs that are clearly not part of your eyebrows. Then tweeze from underneath the brow, removing one row of hair from the beginning of the brow to the end. Pluck the hairs out in the direction of hair growth. If necessary, remove the second row of hair from directly underneath the arch, to open it up. Then remove the hairs I refer to as no-man's-land, those hairs that are not part of your eyebrow or part of your hairline, but

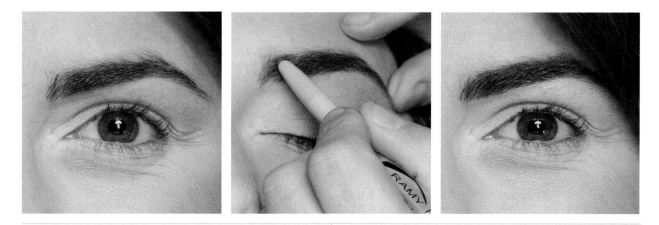

exist somewhere in the middle, fuzzying things up. Lastly, pluck between your eyebrows. It's always a good idea to stop between steps and take a moment. Do something else. Check your phone, for example. Then go back to shaping your eyebrows. When you take those moments, you return to your brow shaping with a fresh eye and more perspective than when you simply rush through the process.

STEP ❸: Using your brush, comb your brows downward. If there still exists excess length, trim it, cutting against the grain. Remember, trim very conservatively. You can always cut off more, but once it's trimmed too much, there is nothing to do but wait for it to grow back! If you follow these simple steps, your brows should look finished and polished, which will open up your whole face and lift your eyes.

Where Should Your Brows Begin and End?

When I first became known as an eyebrow expert, a new client came in whom I immediately recognized. When I was in high school, I used to pose as a potential client and would request the model books from the Ford modeling agency. One of the models listed in their special bookings section alongside Christie Brinkley and Cheryl Tiegs was Chris Royer, who was the designer Halston's muse. I asked her if she used to be a Ford Model, and that broke the ice. She told me that during her modeling heyday, legendary makeup artist Way Bandy taught her the trick of measuring the proportions of your face and then shaping your eyebrows accordingly.

Many makeup mavens are familiar with these measurements, which begin with holding a brush or a pencil vertically against the side of your nose. Where the pencil lands by your brow is where your brow should begin. Repeat on the other side of your nose. Then hold the brush or pencil at a forty-five-degree angle from the base

of your nostril up toward your eyebrow, and where it lands is where your eyebrow should peak . . . or end . . . or something. I'm not really sure because after Chris Royer taught it to me and told me to shape her brows accordingly, I told her that this measuring technique seemed very mathematical, which is decidedly not my specialty and I feared that if I tried to shape her eyebrows using this measuring trick, I might mess up her brows. Chris said, "I've heard good things about you, so forget the measuring trick and just do your thing." I shaped one of her eyebrows and showed it to her. She loved it and said, "Do the other one! Do the other one! But first, let me see something," and she picked up my brush and did the measuring trick on the brow I'd just shaped and it was perfect. I learned in that moment that I have good instincts for brow shaping and that I don't need to use mathematical equations when shaping an eyebrow. The purpose of measuring is meant to be a very generalized template, not to be used literally. For example, if someone has a very wide nose, does that mean that their eyebrows should be overly wide apart? Of course not. So if you're an eyebrow pro or are shaping your own eyebrows, always keep in mind that these rules are meant to be used as a very general template, but they should not supersede your instincts or common sense.

Faking a Perfect Eyebrow

Even the best eyebrows look more flawless when made up correctly. Whether your eyebrows are sparse, thick, or perfect, you can improve and alter their appearance by filling them in correctly.

The three biggest mistakes people make when filling in their eyebrows:

- Choosing the wrong shade of brow filler. If the color is too dark or too warm, the eyebrow makeup will look obvious. Always choose a shade that is one or two shades lighter than your eyebrow hair color. When in doubt, opt for the lighter option. If you have pale blonde or silver hair, go one or two shades darker than your hair color.

- Trying to use makeup to create a brow shape that's not there. Makeup can help enhance your brow shape magnificently if used correctly, but should not be used to artificially create a line that's not there. Don't make the mistake of creating an artificial brow line, but rather, use makeup to enhance your existing eyebrow. Brow filler should be used to make eyebrows look fuller and more dense, to extend the length of the brow a little bit, and to fill in the gaps. Shaving off all or part of your eyebrows and then using brow filler to create an eyebrow will never, ever look good.

- Not blending the brow filler. Simply applying eyebrow filler or drawing on an eyebrow pencil is not enough. No matter what you ever use to fill in your eyebrows, always take a moment to brush through it with a small brush. This removes any excess product and blends what's left behind so that you end up with a great-looking eyebrow, not a made-up-looking eyebrow.

THE UNIVERSAL BROW FILLER

This is the eyebrow filler that will work on every type of eyebrow, any hair color, and any skin tone. I call it "the no-brainer." It's a neutral putty color that will work with your own coloring and not be too dark or too light. In order to truly be universal, the shade must be utterly neutral. If it's a little warm or cool it will not work on everyone. The universal brow filler can come in various forms: pen, pencil, powder, or gel. It's the color that makes the product universal, not the formula.

The Classic Brow

This is the brow fill that will improve everyone's eyebrows, regardless of specific issues. Apply the brow filler to where your eyebrow is or where you'd like it to be. Draw the filler along your eyebrow in small strokes beginning from the front of your eyebrow up to the peak in a straight line and then down from the peak to the end of your brow, also in a straight line. Next, brush through your entire eyebrow to blend the brow filler and remove any excess product. Add a colorless (white) highlighter along the underside of your eyebrows and blend out.

Product to try:
Revlon Brow Fantasy Pencil and Gel, $7.99
Ramy Perfect Brow Wand, $28

Addressing Your Eyebrow Issues

The Skimpy Brow

Even a skimpy, thin eyebrow can be made to look fuller and denser by shaping it strategically. Removing hairs from around the entire eyebrow can make what is left behind look more substantial. Anyone can make a thick, heavy eyebrow look better, but shaping a thin eyebrow and making it look more substantial really requires skill.

The skimpy brow truly benefits from being filled in correctly. It's especially important to choose a neutral or lighter shade of brow filler for a thinner brow. You also want a formula that will adhere to bare areas and last all day, so choose a wax-based formula like a pen, pencil, or pomade. Powder formulas will not look as good or last as long on a thin brow.

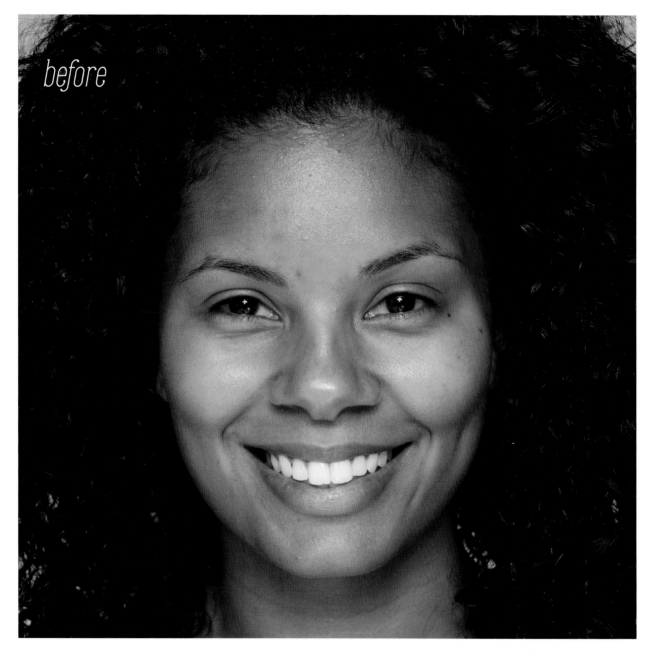

before

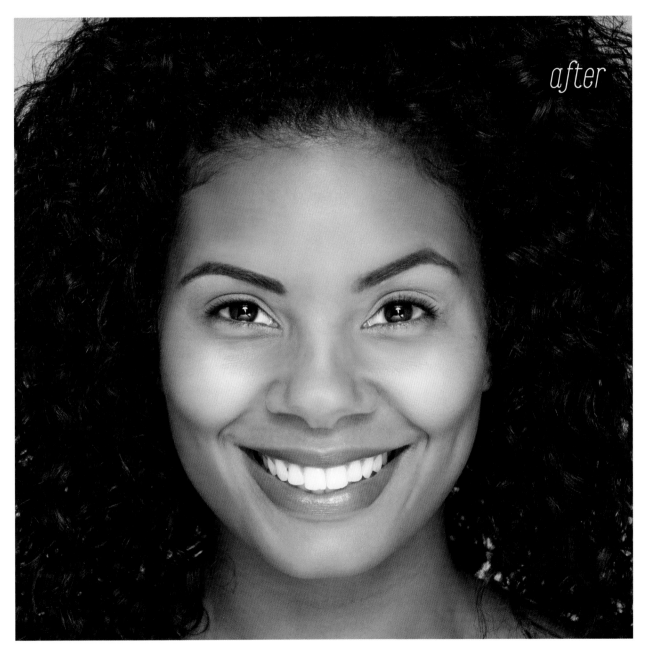

after

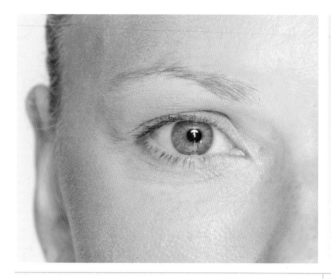
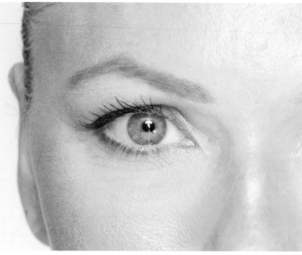

I'm often asked about dyeing thin brows to make them look more substantial. While darkening your eyebrows will make them more visible, it will also make the sparse areas more noticeable; whereas, when you fill your brows with makeup, you're filling in between the hairs, which makes the brow look more dense and plush. Adding concealer along the underside of your eyebrows as well as just above the brows will make thin brows look more substantial, too. Not only will adding the highlighter along the underside of the brow add visual lift to your brows and emphasize your arches, but the contrast between the highlighter and the eyebrow will further make the brow look more substantial.

THE ANGRY BROW

I once did eyebrow makeovers for *Real Simple* magazine, addressing the various eyebrow issues people have and demonstrating the solutions to each brow issue. One of the women who volunteered to have her brows done looked agitated and mad. "What are you going to do to my brows?" she asked. I said, "I'm going to make them look less angry." "Yes!" she replied. She said people always asked her why she was so angry when she wasn't. Her strong eyebrows were a little too close together, with a sharp arch. Shaping them a little farther apart and softening her arches made her expression match her sweet disposition.

If people are constantly asking you why you're angry when you're not, you may have the angry brow. Usually angry brows are a little too close together and often have an excessively sharp arch. To fix an angry brow, you need to remove some hair from the front of the brows and from just below the front and soften the arch by removing some hair from above the peak of the brows. Softening the color will also help, either by having them professionally lightened at a salon or using makeup in a shade that's two to three shades lighter than your eyebrow hair color.

The Heavy Brow

There is a big difference between a full, thick brow and a heavy one. A thick eyebrow can be enviable and beautiful if it is groomed properly. A heavy brow will visually weigh your eyes down and can make you look older and unpolished. The bold brow trend is not an excuse to walk around like a cavewoman. Trimming the excess length off of a heavy brow will dramatically help take the weight out of the brow. Then tweeze as needed, depending on the look you want to achieve.

The Sad Brow

I've also done eyebrow-makeover stories for *Cosmopolitan* and *InStyle* magazines. Another eyebrow issue that always comes up is the sad eyebrow. This makes the person who has them always look like they're sorry about something. The sad brow either curves down in the front or in the back of the brow—or both—giving the person a sorrowful expression even when they are not feeling sad. Uncurving the lines of the brow and straightening out the lines can correct the sad brow so that the brow frames the person's expressions authentically.

The Drag Brow

The drag eyebrow usually occurs when someone has the right idea of what their eyebrow should look like, but the wrong execution. The drag brow usually involves removing too much of the brow hairs—often removing the tail of the brow altogether—and then relying heavily on makeup to create the desired brow shape. This results in an obviously heavily made-up-looking eyebrow that can be seen on *RuPaul's Drag Race*, but it's not ideal, unless you are, in fact, a drag queen.

GUYBROWS

In recent years, men have gone from being about 5 percent of my clientele to being at least 45 percent. Guybrows is a term I coined for men's brow grooming. I've been saying it for years, but in 2011 I was interviewed by the *New York Times* for an article about the boon in men's eyebrow shaping, and the word "Guybrows" was officially born. Since then I've been quoted about Guybrows in the *Wall Street Journal, Esquire,* and *Details* magazines and endless online articles and blogs. As a result, I trademarked the term.

How do Guybrows differ from other brow shapings? Guybrows never look obviously groomed. The brow shaping is far more subtle. While it can greatly improve a man's appearance, it never looks done. While I'm known to be opposed to waxing eyebrows in general, I'm especially opposed to it for men because it leaves a very obvious line and can very easily be overdone.

The number-one concern men have when getting their eyebrows done is that they don't want it to look obvious. When they return for their second appointment, I always ask if anyone noticed they had their brows groomed, and they always say no, which is why they return. Some will say that people remark that they look good, did they get a haircut or lose weight, but they never know it's from a great brow shaping. Like any good brow grooming, however, Guybrows can shave years off of a man's appearance and can be the difference between looking fine and looking amazing. The days of brow grooming leading to feminine results are over.

Eyebrow Myths and Truths

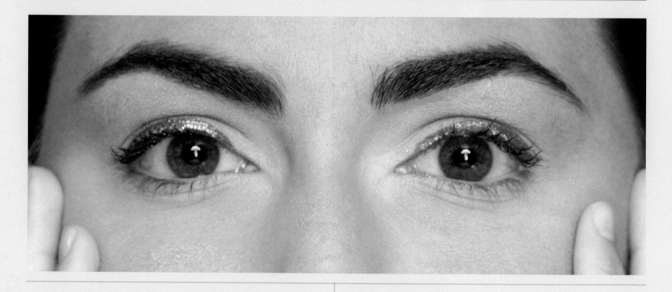

There are almost as many old wives' tales about eyebrows as there are about pregnancy. Here's the absolute truth:

MYTH: You should never remove hair from above the brow.

TRUTH: Someone apparently stated this in a magazine interview thirty years ago, and it's been passed down as law ever since. The truth is that you can remove hairs from above the brow. Just be careful not to remove so much that you remove your peak. I'm pretty certain whoever said not to touch hairs above the brow meant that you should leave it to the pros and remove only from below the brow when maintaining your brows between visits.

MYTH: **Removing hair from your brow will make more hairs grow back or make existing hairs grow in thicker.**

TRUTH: You can only have the hair follicles that you already have. Removing hair cannot and will not make new hair follicles appear or make your existing hairs grow back thicker. This myth came about because when people shave their eyebrows, the stubble appears thicker when it first grows in because you're seeing the cut-off hair end as opposed to the new, thinner growth you'd see after tweezing or waxing.

MYTH: **A thicker eyebrow looks more youthful.**

TRUTH: The truth is that a thinner eyebrow is very aging. This does not mean that growing in your brows to unkempt proportions will make you look younger. If anything, a proper brow shaping with your arch placed correctly will dramatically lift your eyes and make you look years younger.

MYTH: **Removing hair from your eyebrows will make it stop growing eventually.**

TRUTH: While some people swear they were waxed one time and their eyebrows never grew back, the truth is that the hair follicle has to be traumatized in order to die off and stop producing hair. If wax is too hot or pulled off too aggressively, it can prevent hair from growing back. I've met many people who tell me they break out from waxing. This is not a breakout like acne, but rather it's a traumatized hair follicle that has swollen up. Other methods, like threading or tweezing require years and years of repeated hair removal in order to slow or stop the hair from regrowing.

Brow tools to try:
Revlon Slant Tip Deluxe Tweezers, $3.99
Sally Hansen The Now Brow Perfect Arch Brow Kit, $7.99
Ramy Scissors by Tweezerman, $18
Ramy Browtility Brush, $21
Ramy Tweezers by Tweezerman, $25

chapter five ————————————————

HOW TO FAKE
CONTOURING

————————————————————————————

Meet Our Model >

TANYA has a very classic, timeless beauty. She looks like something out of a Raphaelite painting. She was the perfect model to demonstrate realistic contouring as opposed to theatrical contouring.

Even a few years ago only celebrities with a glam squad were privy to the magic of contouring. Today, thanks to the Internet and media, even the best-kept secrets are public domain and accessible to everyone. *Keeping Up with the Kardashians*, could be renamed *Contouring with the Kardashians* thanks to Kim posting pictures on social media of her face in the various stages of makeup and contouring. Last year, Julie Chen, host of *The Talk* on CBS, dispelled rumors of excessive plastic surgery by airing her makeup routine and illustrating that her dramatic transformation was the result of contouring, not surgery.

As a result, what used to be the savvy secret of drag queens and movie stars is now being pursued by everyone who wants to improve their appearance without going under the knife. The key to successful contouring is keeping it real. My philosophy of "Minimum Makeup, Maximum Impact!" really applies here. The objective is not to apply contouring as we see it on *RuPaul's Drag Race* (or even on *Keeping Up with the Kardashians!*), where you see wide streaks of brown and white dramatically blended onto the face, creating a transformation that looks fine on camera but will make you look like a sculpted Baby Jane in real life. Rather, the objective here is to contour and highlight using more subtle and believable colors and achieving great results that simply look like a better, Photoshopped version of you.

Master makeup artist Kevyn Aucoin once said, "The art of makeup is the art of blending." Truer words were never spoken. While blending is key for great results for all makeup you apply, it's most important when it comes to contouring. Nothing looks worse than obvious contouring, and that's what happens when it's not well blended. If you're adding shadow to the sides of your nose, for example, you want the makeup to be imperceptible. You want to create the illusion of a slimmer nose, not create a nose with stripes! For all contouring, if you're not sure that you've blended it sufficiently, pat translucent powder onto the area. This will help soften the effect and keep it looking real.

Playing Hide-and-Seek

Contouring is all about light and shadow. Highlighter (light) brings features forward, and contour (shadow) creates depth. The two used together can create the illusion of a slimmer nose, bigger eyes, higher cheekbones, and a slimmer appearance.

Once you master the technique, you can experiment and customize where you apply the highlighter and shadow to fine-tune your features as desired. Other than blending well, the most important factors for successful contouring are:

Color selection of highlighter and shadow: While you can opt for a highlighter that has color, like a pink or gold shimmer, the best shade of highlighter is white, which is universally flattering for every skin tone because it's essentially colorless when blended out and offers the most dramatic highlight effect.

Even more important is the selection of color for the shadow. Look at the contours of your face. The color of shadow created by the hollows of your cheeks or the shadow on your neck created by your jawline. It's not a flesh tone, but rather the color of a shadow: gray, neutral, almost a putty color. This is the color you should use to contour for the most believable results.

Where you apply the highlighter and shadow: If you place the makeup in the wrong area of your face, it will look obvious or like you have dirt on your face. If you apply it correctly and blend properly, you can enhance your features while looking naturally beautiful.

Contouring Your Nose

TO SLIM YOUR NOSE

Apply the shadow on both sides of the bridge of your nose beginning at the top of your nose, along your eyeline, and ending at the tip of your nose. Blend the shadow up and down, to keep the color in place. Spreading the color out as you blend will ruin the effect you want to achieve.

To Shorten Your Nose

Add the shadow just below the tip of your nose, between your nostrils. Add a dot of the highlighter high up on the top of the bridge of your nose. Blend well. The highlighter will draw people's eyes to the top of your nose, further creating the appearance of a shorter nose.

To Straighten Your Nose

Apply the shadow to both sides of the bridge of your nose. Add shadow below the tip of your nose if desired. Add the highlighter down the center of the bridge of your nose. Blend the shadow and highlighter well, but blend it up and down along your nose to keep the contour where you want it and to avoid blending it out to a part of your nose where you don't want it.

RAMY PRO TIP: Before major photo shoots or red carpet appearances, some famous faces take a decongestant or do a saline rinse to reduce swelling of nasal passages. When you couple this trick with contouring, the results can be like a nonsurgical nose job!

Contouring to Slim Your Face

Look at yourself straight on in a mirror and tilt your chin up. Using a blush or powder brush, apply the shadow from one ear to the other along your jawline. Blend back and forth with an eye toward blending slightly downward. For a softer effect, apply translucent powder or powder bronzer on top of the shadow. Follow with the contouring directions for your cheeks.

Contouring Your Cheekbones

In my opinion the cheekbones are the feature that most benefits from contouring. Contouring your cheekbones correctly can dramatically improve the look of your face, giving you a more defined, elegant appearance. We have all seen women sucking in their cheeks and furiously applying blush to the hollows of their cheeks in an attempt to play up their cheeks. This is old school and completely incorrect. Blush is meant to add a flush of color to your cheeks and is not intended to be used for contouring. Applying blush to the hollows of your cheeks makes you look crazy, not sculpted. To contour correctly, apply the following steps:

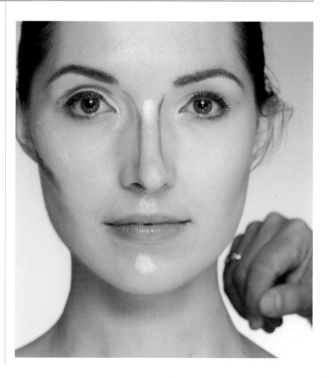

STEP ❶ : Apply shadow in a gray/taupe/putty color to the hollows of your cheeks to create the illusion of more depth. Look at your face straight on in the mirror and note where you see natural shadow in the hollow below your cheekbones. You want to add the contour powder onto that shadow, creating a deeper shadow. Blend the contour powder up and down along this lower part of your cheekbone.

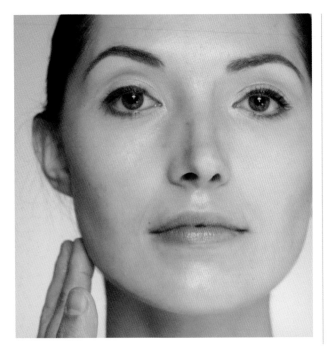

STEP ❷ : Add the highlighter high up on the cheekbone, blending it up and down along the top of your cheekbones. The highlighter should run along the top side of your cheekbones, so that if you turn your head left and right you'll see the light reflection along the upper part of your cheekbones, creating a dewy look on your skin.

STEP ❸ (optional): Smile and add the blush in the desired shade to the apples of your cheeks, blending upward along cheekbones. The blush should land in between the shadow and the highlighter, with the shadow just below the blush and the highlighter just above the blush. Blend so that the three products look seamlessly melded together.

If you opt to skip blush, follow steps 1 and 2 and blend the shadow and highlighter together, focusing your blending on the highlighter so that the contour remains below the cheekbones.

Contouring a Wide Forehead

Apply a thin line of shadow along your hairline from ear to ear. I sometimes use a sable eye shadow brush for all my contouring, because the small brush head offers good control so that you're forced to build the color slowly and you don't apply too much contour powder. Blend well. Follow with powder bronzer or nude blush on top of the shadow. The shadow and bronzer/blush should not be all over your forehead, but rather outlining your forehead.

To further narrow the appearance of your forehead, sweep more bronzer/blush on the outer corners of your forehead, just above the tail end of your eyebrows.

Remember, contouring is all about light and shadow. Once you master the technique, you can experiment and customize where you apply the highlighter and shadow to fine-tune your features as desired.

Contouring Your Décolletage

While Victoria's Secret may be your cleavage's biggest supporter, even surgically enhanced breasts occasionally need a boost from makeup. The same rules that apply to contouring your face apply to your body. If you do want to fake an enhanced décolletage, you want it to look real, not obviously made-up. You can use the same three products that you use to contour your cheekbones (neutral shadow, colorless highlighter, bronzer/blush) to enhance your cleavage.

STEP ❶: Looking at yourself in the mirror, apply the shadow along the underside of your breasts, where you see shadow. You want to enhance the existing shadow line. Extend the shadow along each breast and up between your breasts, keeping the shadow in a fine line that outlines your breasts.

STEP ❷: Using a bronzer or blush brush, apply the matte powder bronzer or nude blush directly on top of the shadow.

STEP ❸: Add the cream highlighter or shimmery powder onto your breasts.

For more subtle contouring, skip the shadow and use a matte powder or bronzer that is two shades darker than your skin tone to enhance the shadow between your breasts, and then add shimmery, light reflective powder or highlighter onto your breasts.

Faking Bigger Boobs

To take it a step further, apply the above contouring and wear a lifting bra. For the look of a full-on breast enhancement (naturally!), add a second lifting bra on top of the first and crisscross the straps behind your back. This may take getting used to as far as comfort, but it will enhance your cleavage dramatically.

You can add shadow and highlight to emphasize your collarbone using the same technique. Apply the shadow on either side of the bone to emphasize the existing shadow and run the highlighter along the center of the bone, blending it back and forth.

Contour products to try:
Ramy Matte Eyeshadow in Neutral Impact!, $17
Kevyn Aucoin The Sculpting Powder in Medium, $44
Make Up For Ever Sculpting Kit, $48

Highlighters to try:
theBalm Mary-Lou Manizer, $24
Benefit High Beam, $26
Ramy Pure Juice Highlighter, $28

When selecting products to highlight and contour, choose matte contour formulas and shimmering highlight formulas. Avoid kits that offer too many shades of contour, as you're more likely to choose the wrong shade. Opt instead for a universal medium shade of contour and a white or colorless highlighter for the most natural and believable results.

Using Bronzer to Contour

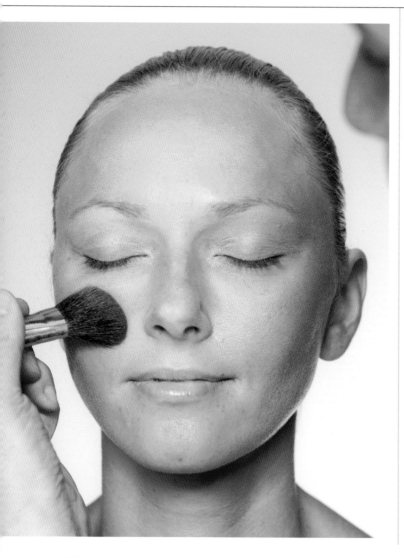

Bronzer is a safer way to go for everyday contouring. Whichever formula of bronzer you opt for, you can easily do a little contouring by adding more bronzer strategically to enhance your cheekbones and jawline or slim your face or nose, for example. This is *only* if you are interested in achieving a very subtle effect. If you're not inclined to create a more dramatic, professional-caliber contouring effect, but prefer to just softly contour, almost subliminally, then adding a touch of extra bronzer strategically can accomplish that.

After applying bronzer, you can contour by adding additional bronzer to achieve the following effects:

SLIM OR SHORTEN YOUR NOSE

Apply bronzer to the sides of your nose, leaving the center of your nose bare. The additional coat of bronzer on the sides of your nose will create a slimming, straightening effect. To shorten the tip of your nose, add bronzer to the lower tip of your nose, between your nostrils. If you want to add highlighter, apply it onto the center bridge of your nose. If you feel the bronzer contour looks too obvious, blend it more, but blend up and down so that you don't spread the bronzer. You want to keep the color targeted on the sides of your nose. Tap a little translucent powder on top of the bronzer to blend in further.

Enhance Your Cheekbones

Add additional bronzer along the undersides of your cheekbones, almost as though you're applying blush, but aim just below where you would apply blush. The bronzer will emphasize the hollow beneath your cheekbones. Add the highlighter high up on your cheekbones, just above where you apply blush. The highlighter reflects light, bringing the cheekbone forward while the bronzer creates depth. The two together create a sculpted cheekbone.

Slim Your Face

Whether you want to enhance your jawline, slim your face, or diminish a double chin, add bronzer along your jawline, blending down onto your neck. The additional bronzer creates depth and shadow.

The key to all contouring is blending so that highlighter and bronzer (or other contour makeup) looks seamless and natural. If you think the extra bronzer looks too obvious, too dark, or unnatural, blend away excess bronzer with a clean brush, sponge, or cotton ball, and simply apply translucent powder over the bronzer to tone it down and dramatically blend it further.

PRO TIP: Amy Keller Laird, Editor-in-Chief at *Women's Health*, says, "I never wear blush or bronzer alone—I always mix them together. I take a medium-size blush brush with tapered bristles and swirl it into the blush, then the bronzer, then do that a couple more times before brushing it onto my right cheek, then my left cheek. Then I repeat the process—mixing blush and bronzer—but start with the left cheek, then the right. I find this combination creates a more naturally flushed look than using either product alone."

chapter six

HOW TO FAKE

A PERFECT, GLOWING TAN

Meet Our Model >

I chose Russian beauty ANGELINA for this chapter because she is naturally fair and I knew she'd look stunning with a tan. The outer glow came from my makeup, but the inner glow was all her!

Most of us discover the instant gratification of a tan in our youth, before we find out that the deep dark tan we strive so hard to achieve is going to cause premature aging, age spots, and wrinkles if it doesn't kill us altogether with skin cancer. It's a high price to pay just because it feels good and makes your eye color pop for a week or so. Thankfully, there are ways to fake a healthy, sun-kissed glow without burning your skin or wreaking havoc on your health and youth.

Some dermatologists claim that the sun is enemy number one to your skin. I personally think a little sun in moderation is okay. While I agree that any tan you get from the sun is technically skin damage, I also believe we need our vitamin D and that life, and the sun, are meant to be enjoyed. The truth is, however, that you can avoid all sun damage and still create a beautiful, glowing, natural-looking tan.

How to Use Self-Tanner

Many people don't know the difference between a self-tanner and a bronzer. A bronzer is makeup in liquid, powder, or stick form that fakes a tan and washes off at the end of the day (see "The Magic of Bronzer" on page 101). A self-tanner is skin care that causes you to produce melanin and, therefore, makes your skin tan. A self-tanner can last for a week through several showers. The mistake to avoid is choosing a formula that's too dark for your skin tone. The longer you leave the spray tan on, the deeper and longer your tan will last.

FAIR SKIN: CHOOSE LIGHT

MEDIUM SKIN: CHOOSE MEDIUM OR DARK

OLIVE OR DARK SKIN: CHOOSE MEDIUM OR DARK

Self-tanners offer buildable color. If you apply the light self-tanner and after a day decide you want more color, simply reapply the light. Applying medium or darker self-tanner will only make your tan look obvious and artificial.

Exfoliate

Whether tanning your entire body or just your face, it's important to exfoliate to remove the dead surface skin so that your tan will last longer, look more even, and avoid the splotchiness that can occur on unexfoliated skin after a few days. So use a scrub, a loofah, or a facial brush before applying the self-tanner.

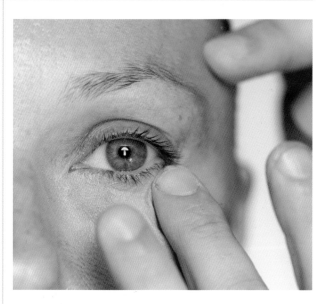

PLAN

Apply the self-tanner when you have the time to let it set. Don't do it right before going to bed unless you have time to let the self-tanner dry and set, or you'll get it on your sheets and won't get a flawless, even tan. I do like to apply self-tanner at night, so that I wake up with my tan ready to go.

Moisturize

Once you've washed off the self-tanner, moisturize your skin to keep the tan going and avoid scrubs for a few days so that you don't wash off your tan.

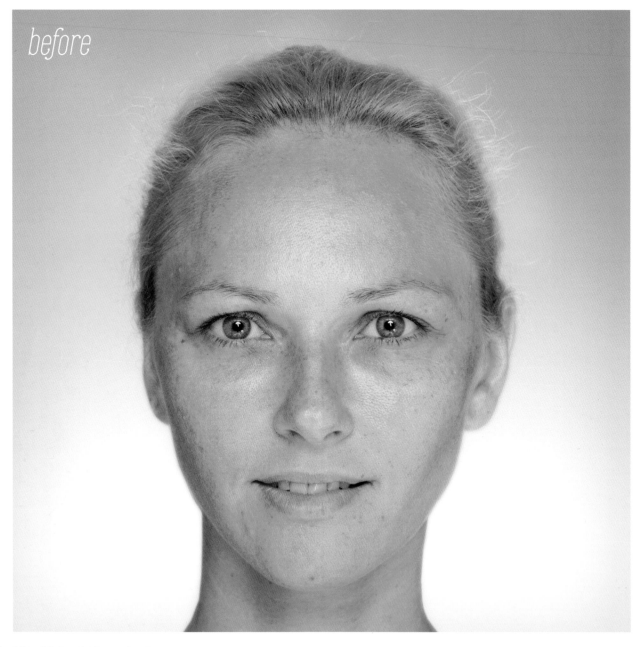

before

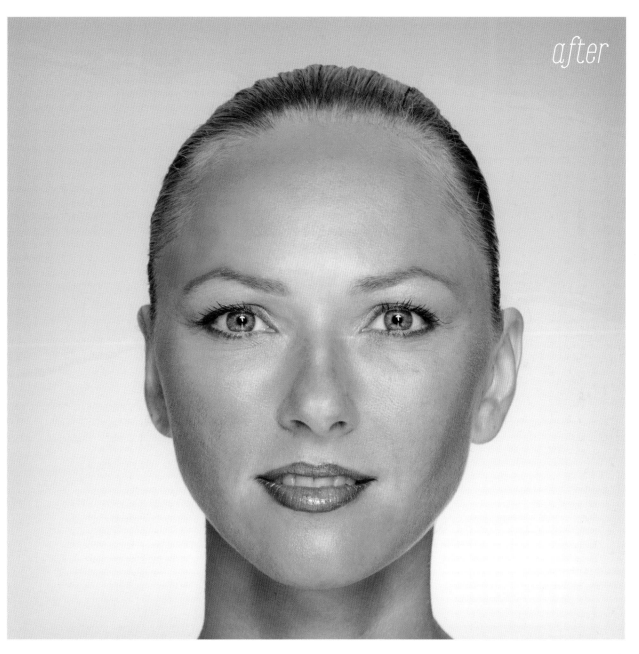

after

Apply

Apply the self-tanner to your face and body as evenly as possible. Many self-tanners are white in color and disappear into the skin. The problem with this is that you can't always tell if you missed a spot until the tan develops. A great trick is to mix a little liquid or gel bronzer into the self-tanner to give it a tint before you apply it. This will help you to spot any area you may have missed with the self-tanner. Use gloves so that the palms of your hands don't get tan. If you don't use gloves, be sure to wash your hands with soap thoroughly and immediately after applying the self-tanner.

Wait!

Stand until the self-tanner dries. Don't get dressed right away or sit or lie down, as you will mess up your potentially even tan. Let it set for twenty minutes or so for the best results.

PRO TIP: Celebrity spray-tan expert Anna Stankiewicz advises, "Using a self-tanner moisturizer is the best way to prolong your spray tan at home. It adds subtle color without leaving buildup or streaks. Going with a light tan is the best way to achieve a healthy glow."

How to Perfect Your Spray Tan

Spray tans are great if you're not inclined to self-tan at home. You do get a richer, more long-lasting tan from a professional spray tan. Some tanning salons offer machines that spray-tan, while others have people that spray-tan you. Both are excellent, though with a live person, the tan is a bit more flawless and the "spray artist" can contour your body with extra shots of color where desired. You can deepen your abs, shade in love handles or thighs, and really customize your tan. A live person also has experience and can suggest how light or dark your tan should be, depending on your desired results.

If you opt for a machine, choose a shade that's one shade lighter that what you think you want. This way you can try it out, and if you want a deeper tan, you'll know what to choose on your next visit without having to live like an Oompa-Loompa for a week.

Depending on the formula you use, it's also a good idea to keep it on for several hours. I like to get a spray tan at the end of the day and then sleep in it. When I shower in the morning, I'm left with a beautiful, natural-looking tan.

A Note on Tanning Beds

The worst solution. Tanning beds can cause irreparable damage to your skin and significantly increase your risk of skin cancer. In my opinion, tanning beds are far, far worse than the actual sun. With all the other wonderful options to achieving a tan, there is no need to ever use a tanning bed.

PRO TIP: Celebrity spray-tan expert Anna Stankiewicz says, "Spray-tanning is a much safer option because you're not damaging your skin with UV rays. Tanning beds cause wrinkles and sun spots (dark pigment patches). You can get skin cancer from tanning beds. Getting burned one time in a tanning bed increases your chances of skin cancer by 80 percent."

The Magic of Bronzer

Bronzers are a terrific, no-commitment way to achieve a healthy, glowing tan. The key is to find the right formula and the right shade of bronzer for a natural effect. Bronzers are also a great way to add longevity and enhance self-tanners. The key to success with bronzers is to choose a shade that's lighter than you think you want. Like blush, bronzer can oxidize on your skin and look darker or more intense than you intended. If you choose a lighter shade, you can build the color by adding more as needed.

RAMY PRO TIP: Applying bronzer on your legs can conceal cellulite and varicose veins and make your legs appear slimmer. Spray makeup-setting spray onto your legs to make your bronzer transfer-resistant so that the bronzer stays put and you won't get stains on your clothes.

Setting sprays to try:
Model in a Bottle Original Makeup Setting Spray, $18.00
Skindinavia The Makeup Finishing Spray, $39.00

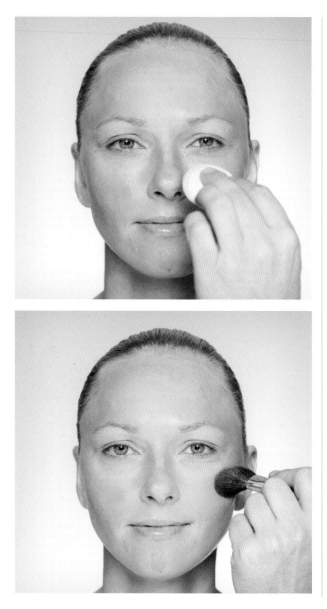

Powder Bronzer

This is the most commonly used formula. Powder bronzers are easy to use. I suggest a matte formula for anyone over nineteen. Formulas with shimmer or sparkle are fun, but a matte formula offers the most natural results. Use a matte formula and add shimmer with a highlighter high up on your cheekbones, down the center of your nose, and on the center of your chin if you want to add sparkle to your tan. With powder formulas, I find that light shades tend to be too orange and dark shades too red. A medium color will suit most people. If you're fair, use less and blend more. If you're medium-skin-toned, a medium bronzer still offers buildable color and can look naturally sun-kissed on darker complexions.

The key to achieving great results is to keep it in the natural realm. Many people think that if a little bit of color makes them look good, then a lot of color will make them look better. Wrong! A little bit of tan can make your skin glow and your features pop. Too much bronzer (or too dark), and your fake tan looks obvious, cheap, and flat.

The key to a beautiful and natural-looking tan is to apply the powder bronzer onto the areas of your face where the sun would naturally tan you. Using a blush or bronzer brush or an applicator puff, apply the bronzer onto your cheeks, along your hair line, across the crease of your eyelids, the sides of your nose, and on your chin, blending down to include your neck.

Powder bronzers to try:
*Physicians Formula Bronze Booster Glow-Boosting
 Pressed Bronzer, $14.95*
Guerlain Terracotta Light Sheer Bronzing Powder, $52

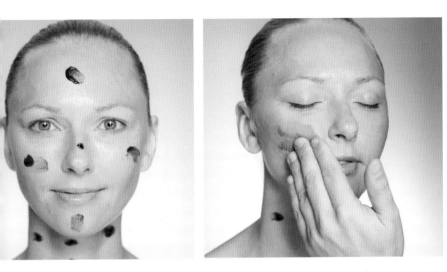

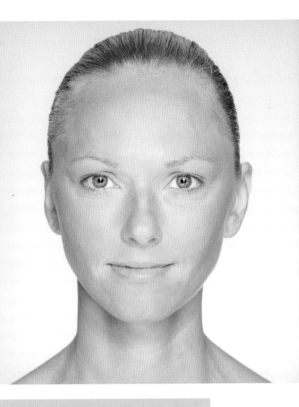

LIQUID OR GEL BRONZER

Liquid or gel bronzers are incredibly versatile. You can dab them where desired on your face or body, or mix them into your foundation or moisturizer. Like powder bronzers, medium shades of liquid or gel bronzers tend to suit most complexions and offer buildable color. Liquid or gel formula bronzers are also ideal for tanning your body.

Apply a pea-size amount of the bronzer to each cheek, your forehead, nose, chin, and neck. Blend well, using your fingers or a sponge. If you're mixing your bronzer with a moisturizer, tinted moisturizer, or foundation, mix the products together in the palm of your hand and then apply to your entire face as you would your moisturizer. If applying the liquid or gel bronzer to your body, apply as you would a body lotion, blending well to avoid color streaks or missed spots. The good thing about a liquid or gel bronzer is that you can see the color instantly so you can correct any missed areas or streaks.

PRO TIP: **Celebrity tanning expert Anna Stankiewicz says, "Don't overdo it—less is more. Try to go for the natural look—don't go too dark where it's not believable to your skin tone. You don't want to be eyeballs and teeth!"**

Liquid or gel bronzers to try:
Estée Lauder Bronze Goddess Luminous Liquid Bronzer,
* $28.50*
Ramy Sun Smooched! Bronzer, $32

HOW TO FAKE A MORE

RADIANT SMILE

AND BRIGHTER TEETH

Meet Our Model >

BROOKE has the most gorgeous complexion and beautiful smile. She's a great example of how true radiance starts from within.

find nothing more beautiful than a warm, genuine smile. Nothing throws me more than when I meet a spectacular beauty and she turns out to be humorless or stone-faced. A beautiful smile is not just inviting, it also evokes confidence, happiness, and likability. Whiter teeth can make you appear more sophisticated, younger, and transform your overall appearance.

Today there is no reason why everyone can't have a great smile. There are solutions for every budget to whiten and brighten your teeth. We also have cosmetic dentistry options that can address any issue and correct even the most snaggle-toothed smile into a vision of perfection. Learning which lipstick or lip-gloss color to use to further brighten your smile as well as some tricks of the trade, and you'll have a megawatt smile in no time.

6 Steps to Luscious Lips

STEP ❶: Exfoliate and moisturize. There are many lip-scrubbing products you can purchase, but you can also simply brush your lips with your toothbrush and toothpaste or apply a lip balm or oil. Leave it on for two minutes, then wipe it off and reapply.

STEP ❷: To add the illusion of a poutier lip, start by applying foundation or concealer onto your entire lips and blend it in.

STEP ❸: Take a nude lip pencil and outline your lips, with an eye toward building fullness. Stay in the realm of reality! The objective is not to create porn-star lips, but rather to make your lips look naturally fuller. If you have dark skin, opt for a brown pencil. The key is to use a color that's the same shade as your lips or two to three shades darker than your natural lip tone. A lip pencil that's a little darker than your own lip color will create the illusion of depth and, therefore, a fuller lip. Lining your lips will also prevent the lip color from bleeding.

Begin on your upper lip, drawing the liner in a V to emphasize your cupid's bow and then extending the liner to the outer edges of your upper lip. This is especially helpful for building up a thin upper lip. Then apply the liner on your lower lip, beginning at the center of your lower lip, working the pencil back and forth along your lip line and extending it to the outer ends of your lips.

STEP ❹: **(optional):** Add a dot of the colorless highlighter directly onto the center of your cupid's bow and blend. Then add the same highlighter directly under the center of your lower lip and blend out. The light reflection of the highlighter will give you the illusion of poutier, fuller lips.

STEP ❺: Once your lips are outlined, fill them in with the lip gloss or lipstick of your choice. As a rule, lip gloss is more moist and youthful than lipstick. Lighter, glossier, and shimmery shades all reflect more light and create a fuller lip effect than dark, matte colors. If you prefer richer colors, they can work well, too, and a good tip is to apply a clear or shimmery gloss on top of your bold lipstick to add youthful moisture and light reflection.

STEP ❻: After you've applied your lipstick or lip gloss, put your index finger in your mouth and close your lips firmly around your finger. With your lips still closed around your finger pull your finger out of your mouth. Any lipstick that would have ended up on your teeth will now be on your finger, forever ending getting lipstick on your teeth.

Lip pencils to try:
MAC Lip Pencil in Spice or Mahogany, $15
Ramy Lip Pencil in Laugh Line! or Pick Up Line!, $15
Bobbi Brown Lip Liner in Brownie Pink or Dark Chocolate, $22

Lip Injections: The Good, the Bad, and the Ridiculous

Everyone admires lips like Angelina Jolie's and Kerry Washington's, but not everyone can have them. I've always been of the mindset that lip injections have not yet been perfected

enough to look good. However, I was at an event recently where a well-known Park Avenue dermatologist was the party favor, offering free Botox and Juvéderm injections to

anyone willing to get them. Of course I was captivated as I watched the doctor fill foreheads and cheeks, and I was able to drink in the whole thing and watch the before and after of his subjects. Everyone seemed thrilled with their results, but I wonder if they felt the same way a few weeks later as the filler settled in. One young woman wanted to have her upper lip filled. I looked at her and understood why. Her upper lip was so thin that it was nearly nonexistent. I watched as the doctor quickly injected her upper lip. While I know that the immediate result is not what the end result will be, she suddenly had a nice upper lip! It changed my opinion of lip injections. After much research I've concluded that lip fillers can look great if not overdone and if administered by a doctor who is experienced. When you see overblown, obviously injected lips, it's the work of an inexperienced doctor or the result of a patient demanding more than needed.

They key to great results is to stay as close to your natural lip as possible. Obviously, the reason you would consider lip injections is because you want to plump up and enhance your lips, but keeping it moderate will help prevent becoming a caricature of yourself.

Lip-Plumping Products

There are many products that claim to plump your lips temporarily. Some simply increase blood flow to the lips by irritating the area with ingredients like mint or cinnamon. Other products actually increase collagen in your lips with ingredients like hyaluronic acid or plump by irritating the area with fruit acids or a scrub.

While lip-plumping serums and glosses have varying results depending on the brand, the bottom line is that some work and some don't, and it's a matter of trial and error to find the ones that will work best for you. Even the most effective formula will offer temporary results at best.

Lip-plumping products to try:
Ramy Lip Oils, $18.50
Smashbox O-Plump Intuitive Lip Plumper, $25.50
FusionBeauty LipFusion Micro-Collagen Lip Plump Color Shine, $36

PRO TIP: Dermatologist David Bank says, "Injection with filler can accentuate the red of the lip, thus making pale lips look more pigmented."

Your Brightest, Most Confident Smile

KEEP IT CLEAN

Maintaining your dental hygiene is the key to a beautiful smile, and dental health is the groundwork for having the most enticing smile, possible. Daily flossing to massage your gums and remove debris stuck between teeth will also keep your breath fresh. When you don't floss regularly, bacteria develops that can lead to gum disease (which can cause receding gum line) and an increased risk of heart disease. I highly recommend getting a sonic toothbrush, which will help keep your mouth its cleanest as well as massage gums.

BRACE YOURSELF

We generally think of braces as something we must endure during childhood (I know I did!), but, in fact, adult braces are surprisingly common and used to either address issues that were not corrected during childhood or to correct issues that can develop during adulthood. Many adults' bottom teeth become crooked during middle age due to tongue thrusting or general wear and tear. Correcting this with braces like Invisalign or by wearing a retainer at night can keep your teeth perfect for years to come and restore a confident smile.

White, Whiter, and Whitest

What was considered nice white teeth twenty years ago would be considered yellowish today. While the basic ingredients used to whiten teeth are essentially the same as they've always been—baking soda and hydrogen peroxide—today we have technology like LED lights, which speed up and enhance the whitening effects of hydrogen peroxide. This technology used to be available exclusively at your dentist's office, but now there are equally good at-home devices.

White

There are wonderful over-the-counter whitening products on the market today that can really whiten teeth effectively and help keep them that way. Whitening toothpastes, whitening mouthwash, and whitening boosters—which are hydrogen peroxide gels you can add to your toothpaste—all help to lighten your teeth several shades.

Whitening toothpastes to try:
Arm & Hammer Truly Radiant Toothpaste, $3.48
Listerine HealthyWhite Restoring Mouthrinse, $8.99
Arm & Hammer Whitening Booster, $6.99

Whiter

For more serious whitening, opt for whitening strips, which hold the whitening ingredients against your teeth and help keep them away from your gums to avoid the pain and sensitivity that can occur. Whitening pens are effective and can help target which teeth you want to whiten. Your dentist can also create a custom tray for you to use with whitening gel for more intense brightening than over-the-counter products.

Whitening products to try:
Crest 3D White Whitestrips, $10.99
IntelliWHiTE Pearl Stain Eraser Pen, $39.50

Whitest

Seeing your dentist for a Phillips Zoom! WhiteSpeed light treatment will offer the fastest, most dramatic whitening of your teeth. There are also at-home devices that channel the same light technology.

Note that some discoloration can occur from beneath the tooth's surface, such as from tetracycline, an antibiotic given to pregnant women and children in the 1950s and 1960s. All the bleaching in the world will not correct this, and the only solution is to get porcelain veneers or caps. The upside of needing veneers is that other than just correcting the color of your teeth, veneers can correct your bite and the shape of each tooth to create a stunning smile.

Q & A with Dr. Jennifer Jablow

Dr. Jennifer Jablow is a celebrity cosmetic dentist and creator of IntelliWHiTE products.

Q: Other than whitening strips, whitening toothpastes, and rinses, is there a way to whiten your teeth at home?

A: There are other options to whiten at home. My latest product, CoolBlue by IntelliWHiTE, employs similar technology to the Zoom! light you see in the dental office. Three things need to exist at once for the light to work, which most at-home lights don't have: LED lights with enough power to activate the whitening, a photocatalyst ingredient, and hydrogen peroxide. They create a chain reaction to break the peroxide down faster and smaller to reach the deepest stains other types of whiteners can't. You can get five shades whiter in thirty-five minutes with CoolBlue. A light with just peroxide and no photocatalyst ingredient will not work; that's a scientific fact.

Q: To whiten teeth professionally, are laser and chemical bleaching the only solutions, other than veneers/caps? Is one method better than the other? If so why?

A: There is also composite bonding, but it stains very easily on large areas and also doesn't have a lifelike quality because it looks very opaque.

What are the pros and cons of laser or chemical bleaching? I don't like whitening with a laser because it gives off heat, which can damage the tooth nerve and also causes sensitivity. I like the new Zoom! that is LED light, which whitens more gently. It is very strong in peroxide so once a year is the most I allow. Teeth are very porous, so you need to maintain daily. I like a booster gel that you add to your toothpaste twice a day to fight any stains from food, coffee, or anything with color.

Q: What is the best advice/trick you've learned to brighten your smile or fake whiter teeth?

A: A lip gloss that has some shine to it as the light reflection also makes teeth appear whiter. A matte lip makes teeth appear dull. IntelliWHiTE also makes a stain eraser pen with pearlized pigments, which is a great way to fake white teeth in a photo by just swiping it on right before saying cheese.

Q: I've heard that some women of a certain age have their teeth elongated to give themselves a stronger jawline?

A: It's actually rebuilding the vertical height of the bite and broadening the sides of the teeth, which gives the lips support and creates a tighter scaffold for skin to drape. As we age, our teeth shorten—some people more than others, especially if we grind our teeth at night. Rebuilding the vertical dimension helps rebuild the lower third of one's face.

How to Fake Brighter, Whiter Teeth

A great smile is not only about having straight, uniform white teeth. It's also about having healthy gums, moist lips, and good coloring. While regular maintenance and daily flossing and brushing help to maintain oral health, there are tricks of the trade to enhance every part of your smile.

SHINE

Teeth and lips that shine reflect light, adding brightness to your smile. The age-old trick is to apply Vaseline (petroleum jelly) onto your teeth. The petroleum adds shine to reflect light and makes it easier to smile wider. We all know that Vaseline can be used to condition lips, too. Clear lip balm or lip gloss can also be used on teeth to add quick temporary shine. Coconut oil works well, too. Either paint the oil onto each tooth, or simply gargle with the coconut oil for a minute to cover all your teeth for added shine right before taking that selfie.

Color Rinse

Any blue mouthwash will leave your teeth looking a little whiter because the blue rinse counteracts the yellow in your teeth. A red mouthwash (often cinnamon-flavored, but not always) will intensify the color of pale gums. The intensified shade of your gums will make your teeth look whiter by contrast. Some makeup artists use red food coloring to redden the gums by brushing the food coloring onto the gums with a toothbrush. I've also heard of people using cherry Jell-O

mix on their gums to redden them. I prefer a red mouthwash because it has the added benefit of improving dental health and giving you fresh breath! A whitening mouthwash will not only make teeth whiter temporarily, but with regular use can keep teeth stain-free and at their whitest.

Makeup Choices That Can Help Brighten Teeth

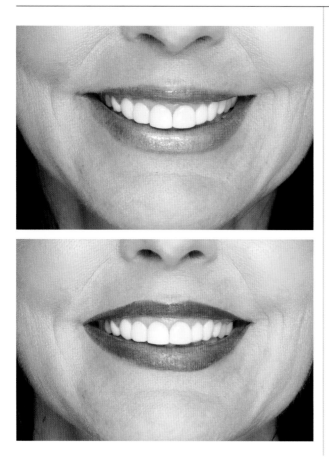

The shade and formula of your lipstick or lip gloss can either make your teeth look whiter or more yellow. There are cool shades (blue-based colors) and warm shades (yellow-, brown-, or orange-based colors). Many makeup artists suggest blue-based lip colors to make your teeth look even whiter. I disagree. While a blue rinse will counteract the yellow in your teeth, a blue-based lipstick or gloss surrounding your teeth will only contrast with the yellow in your teeth, making them appear more yellow. Opt instead for warm-toned lip colors that are yellow-, orange-, or brown-based. The contrast of a yellow-based color, for example, will lessen the appearance of yellow in your teeth, making them appear whiter by contrast. This is a similar concept to choosing an eye shadow color to enhance your eye color. A warm, earth tone like bronze, copper, or brown will make blue eyes appear more blue, whereas blue eye shadow will wash out blue eyes.

If your teeth are bright and white from at-home or professional whitening treatments, a blue-based lipstick shade will be flattering, but if your teeth are yellower than you'd like, a blue-based shade will only make the yellow more apparent.

If you're not one to wear bold lip color, even a natural lip-toned shade will make your teeth look a little whiter by deepening the color of your lips slightly.

FORMULA

The texture and finish of your lipstick or gloss also affects the appearance of your teeth and smile. You want a formula that reflects light to add sparkle to your smile. Choose a lipstick that is sheer or that has shimmer. Both of these qualities reflect light. Lip gloss reflects light just by being glossy, but a lip gloss with shimmer will reflect light even more than a gloss formula alone. Matte lipsticks are long-wearing but have a dull finish and will dull the look of your teeth. If you have a matte formula lipstick you love, add a shimmery gloss on top. Sheer formula lipsticks are moist and almost glossy in finish, so sheer formulas are a good option for whiter-looking teeth, too.

PRO TIP: Melanie Chadwick, Beauty Editor of *Shape* magazine, says, "Matte lipsticks tend to be drying, but the color payoff is so good that I can't give them up. That said, I'll apply lip balm before and after lipstick: a little balm while I get ready, blot, lipstick, then a touch to the center of my lips. It makes them look plumper, too."

chapter eight

HOW TO FAKE
GORGEOUS HAIR

Meet Our Model >

I originally chose ASHLEY for this book because of her fabulous lion's mane of hair, but she would win Miss Congeniality in a pageant. All the other models raved about how kind and sweet she is. She believes in paying it forward and volunteers with several charities in her free time.

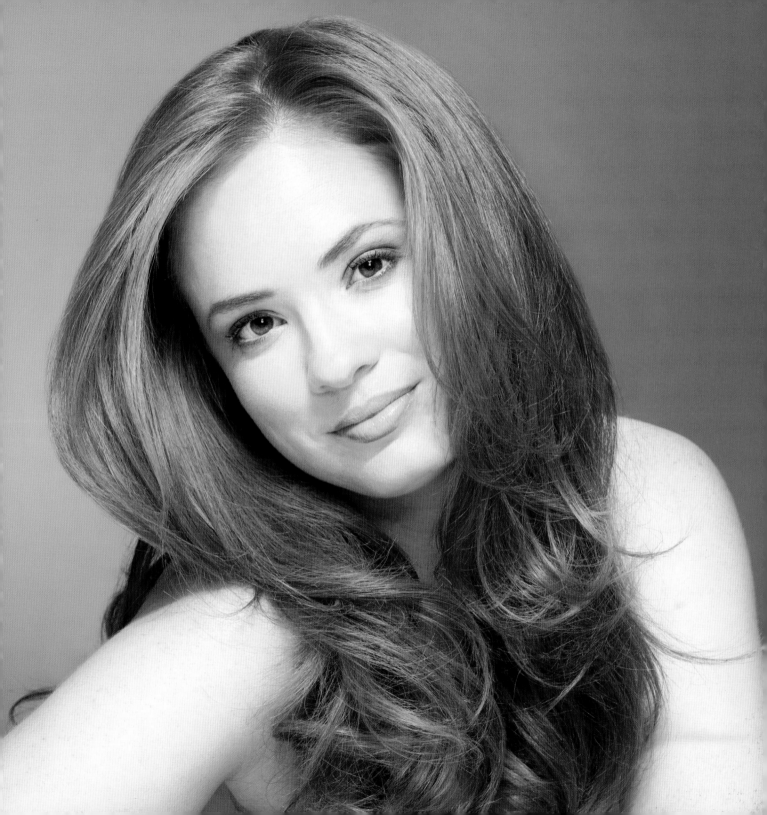

Let's face it: for most women their hair is their crowning glory. We judge and are judged by others on how good our hair looks. Many develop a lifelong relationship with their colorist or stylist with a fanatic loyalty usually reserved for rock stars. More money is often spent on straightening, coloring, styling, and smoothing hair than on any other feature we possess. Our obsession with hair products makes people's bathrooms look like the hair aisle at Walgreens.

Even the most genetically blessed, beautiful head of hair requires care and effort to achieve and maintain its best health and appearance. I'm personally so into hair care that I can tell if someone hasn't conditioned their hair just by looking at them.

The style and color of your hair can completely transform your image and how you're perceived by others. We all have preconceived notions of what type of person rocks a certain style of hair. For example, what do you assume about a woman who has "helmet hair," the overly hair-sprayed, stiff hairstyle that was a staple in the 1960s? What do you perceive when you see someone with a mullet? Dreadlocks? How you wear your hair tells the world who you are as a person, and the optimum style and color can enhance your appearance dramatically.

I always think of the expression "the grass is always greener on the other side of the fence" when it comes to hair. Those of us with curly hair (like me!) long for straight, flowing locks. Those with straight hair want nothing more than body and waves in their hair. While I believe that your best hair is usually close to what you have naturally, I have seen remarkable transformations and know that with today's talent and technology, the hair you desire is pretty much attainable. More than once, a client with straight, long blonde hair has told me that their natural hair looks like my black, curly hair. Whatever style you want your hair to be, it all begins with a healthy scalp, which results in beautiful hair.

PRO TIP: Nunzio Saviano of Nunzio Saviano Salon in New York says, "Good hair is shiny and has body, so whatever it takes—get that look! Shiny, thick hair with body looks beautiful, so avoid flat hair. It doesn't look like it has life."

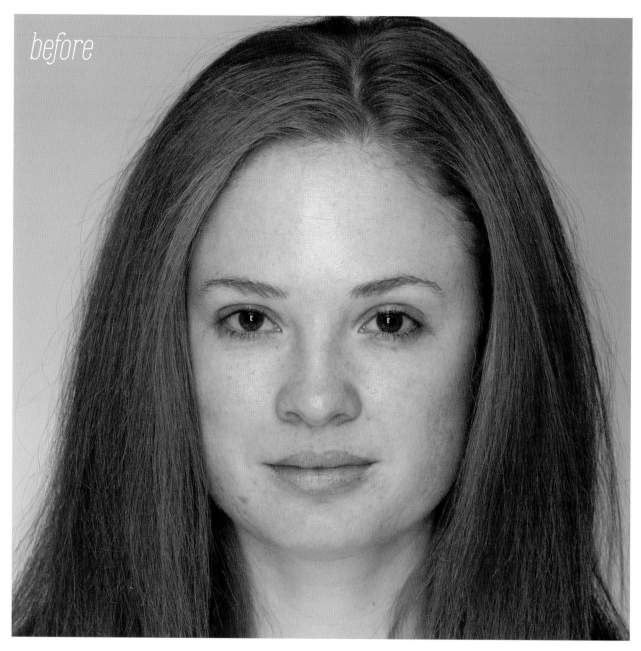

before

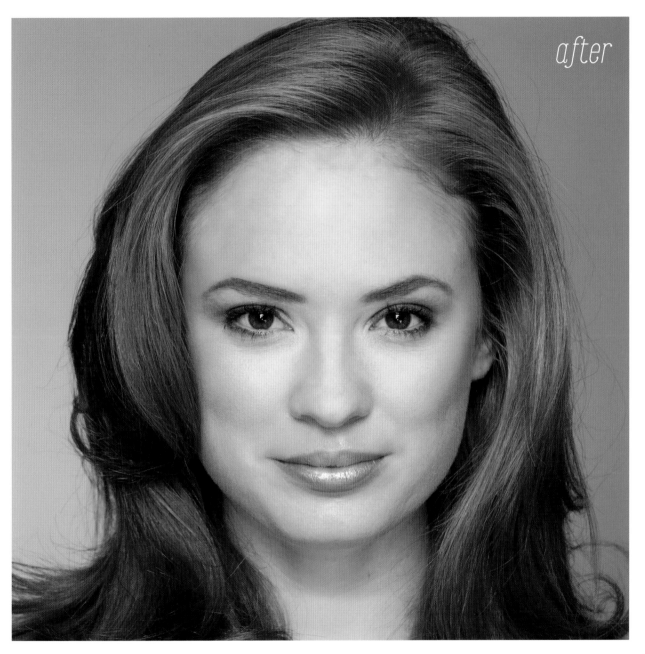

after

Nunzio's Dos and Don'ts for Beautiful Hair

- To thicken thin hair, extensions are a good option and sometimes the only solution to help thin hair look fuller.

- Coarse, frizzy hair looks best when blown out, to smooth and bring out the shine.

- Use a straightening balm or serum to extend a blowout and add sheen.

- You don't want perfectly blown-out helmet hair; you want movement. Older women have moved away from the glamorous look of a generation ago to a look with texture, layers, and movement. Back in the day pomade was for men; today you can use it on women for youthful hair that moves and is free, not a stiff "perfect" look.

- If you're in your fifties or sixties, never, ever, ever have your hair as dark as when you were in your teens. It brings out shadows and wrinkles if too dark, so lighten and brighten it up by highlighting, focusing more light in front. Gray hairs, while making us look older, also soften your appearance, so follow nature and turn the gray to highlights. Think of men's hair. Gray looks distinguished but mature. It's the same with hair color. If dyed to one flat color, it looks like shoe polish, not younger. So if you color, it should have dimension.

- Don't ignore the importance of a clean scalp. Don't shampoo so much that you strip your hair, but keep it clean. You wouldn't go a week without washing your face, so why would you do that to your hair? Your scalp needs to breathe in order for hair to be healthy and beautiful, so use shampoo, massage your scalp, brush your hair, and get trims to keep your hair healthy and beautiful.

- No matter how expensive hair conditioner is, it won't fix split ends. Trimming is the only solution. Quality products keep hair healthy, but it's a combination of shampoo, conditioner, brushing, and cutting that keeps hair gorgeous.

- The old saying of brushing your hair one hundred strokes per day is not an old wives' tale; it's true. You must brush to stimulate your scalp and distribute the oil from your scalp through your hair, which is the best oil you can use on your hair. It also keeps your hair cleaner.

Solutions for Thin/Flat and Coarse/Frizzy Hair

THIN/FLAT HAIR

Thicken: Shampoos and conditioners formulated to volumize and thicken hair can really help, but thickening serums are a true solution to make your hair look fuller than it actually is.

Go lighter: Lighter hair looks fuller than darker hair. This doesn't mean that a brunette with thin hair needs to go blonde, but "bumping your base" to lighten your hair a shade or two, or adding highlights to frame your face will give your hair a fuller appearance.

Pump it up: Brushing a dry shampoo through your hair will absorb excess oil and give your hair a thicker look. There are products that offer hair-thickening fibers to add volume and thickness. Toppik Hair Building Fibers ($6.95 to $24.95) are a colored keratin protein that you sprinkle on thinning areas of your dry hair before you style, but dry shampoo or baby powder can have similar effects in a pinch.

Back-brush your hair: Brushing your hair from back to front with a hairbrush (not a comb, which won't grab as much hair or spread it as much) will double your volume. Hold your head upside down and add hair spray at the roots. Once upright use your fingers to brush your hair back into place. Megavolume!

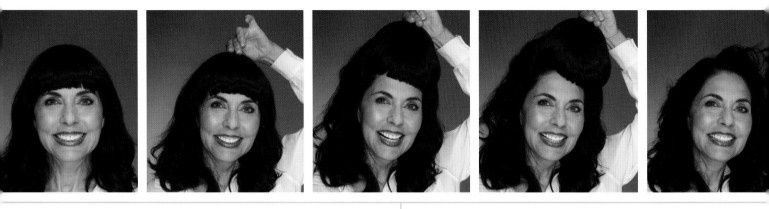

Add layers: Thin hair that is all one length will look its thinnest. Having layers cut into your hair will create the illusion and feel of fuller hair.

Extend it: Extensions glued to your existing hair are great for adding length, but they won't necessarily make your hair look thicker. Hair extensions that are "tracked" involve braiding your hair so that it's flush to your scalp and then sewing tracks of hair onto the braids. While this can look amazing, it's cumbersome, often painful and uncomfortable, and not recommended for ongoing use. Tracks are best for special occasions, but frankly, it seems like a great deal of effort and cost and I think there are wonderful wig options that can do the job every bit as well.

Clip-in hairpieces: These are wonderful because they help you achieve any look you desire, but don't require a commitment. They can look more natural and believable than wigs because they blend in with your actual hair. They are really great for extremely thin hair. You can also simply slick back your hair and clip on a piece in the back to achieve a fuller look. You can put them on and take them off very easily.

PRO TIP: Kayla Spears, Beauty and Fashion Assistant at *OK!* magazine, says, "A simple trick to fake longer, fuller hair is to create two ponytails layered on top of one another. Start by pulling hair back as if you were pulling it half up/half down, then gather the remaining hair into another pony tail and position it directly underneath."

Coarse/Frizzy Hair

Keratin: These treatments can really smooth coarse hair and make it more manageable. I tried it and found that it did straighten my curly hair, even though I was assured it would not. While my hair was straighter, it was also amazingly frizz-free and manageable.

Tame it: Anti-frizz serums work well, but really must be used correctly. Applying serums too heavily can weigh down hair too much and cause dryness or tackiness, which leads to more frizz.

Gloss: Products that add gloss to the hair are wonderful for smoothing hair. Gloss will not only add shine and create a smoother hair follicle, but hair will be more manageable without compromising the curl or texture. Glosses can be done at a salon or at home.

Oil up: Hair oils and the products that contain them are especially good for thick, dry hair. Moroccan oil, argon oil, bamboo oil, and some new products that offer a blend of different oils can work wonders as a pre-shampoo treatment or when added in small amounts, as a hair fixative. Coconut oil is awesome as a conditioner and as a pomade or shine enhancer.

Darker is better: Contrary to fine hair, highlights can exacerbate frizziness in coarse, curly hair. Coloring your hair a deeper shade deposits color to your hair shaft and coats your hair, helping to make coarse or frizzy hair more manageable.

Even out: Layers will add unwanted volume to thick hair. Keep hair uniform in length for maximum smoothness and manageability.

Grow it out: Shorter, thick hair has more volume. As your hair lengthens, the weight of the hair will make your curls more manageable and easier to control.

Ramy's Dos and Don'ts for Beautiful Hair

- Make sure to have enough protein in your diet. Protein is one of the key building blocks of hair.

- Take a good multivitamin daily with a meal to ensure your body has the optimum nutrition. If you have an issue with thinning hair, prenatal vitamins are recommended for their high levels of folic acid and iron, and take biotin supplements.

- Stimulate your scalp to increase blood flow by massaging your scalp, brushing your hair regularly, and using shampoo or conditioner that contains tea tree oil or mint extracts.

- Keep your hair and scalp clean. Use water-soluble hair products.

- Every man I've ever met who used hair spray regularly is bald or balding. Draw your own conclusions.

- Hair spray for women looks dated, old-fashioned, and stiff. If you're using hair spray, ask your stylist to suggest a different product. Your hair will look sexier and more youthful without it.

- Over-processed hair never looks good. Decide what is most important for your appearance. For example, having your hair colored or straightened? One or the other can look great; both together might not.

- If you color your hair at home to cover the gray, find the shade that matches your hair color exactly and then choose one that's two shades lighter. The lighter shade will cover your gray, turning gray hairs into believable, subtle highlights.

PRO TIP: Jenny Jin, of *Real Simple* magazine, says, "When using dry shampoo, make sure to follow all of the directions on the label. So many people, including myself, have used it or currently use it incorrectly. The instructions are usually: shake well, spray from eight to ten inches away in quick bursts (less is always more with dry shampoo), and allow it to sit and soak up oils for at least two minutes before massaging it into your scalp, and finally, brush out the excess."

RAMY'S MOM, RACHEL, OFFERS: "I never cry over my hair and nails (as in, bad haircut or manicure) because they always grow back!"

Getting Out of Your Hair Rut

Even more common than getting into a makeup rut is getting into a hair rut. It's human nature to find a general style and stick to it. This is fine unless your hair starts to look outdated or not as youthful and flattering as it could be. It's been said that people tend to keep the color and style of the hair they had when they were happiest. The problem with this is that your staple look will seriously date you, often making you appear older than you are. I refer to it as "Yearbook Hair" when I meet someone and I can tell that they have the same haircut they had in high school.

A great stylist will not only take into account the texture of your hair and your personal style, but also your bone structure. While someone may look fine with long hair, they might be utterly transformed with a short haircut. Supermodel Linda Evangelista, while always stunning even with long hair, saw her career skyrocket when she cut her hair short. Suddenly the pretty girl had amazing cheekbones, and her features jumped off the page of every magazine.

PRO TIP: *Health* magazine's Beauty Editor, Aviva Patz, says, "Protect your scalp at the beach by tapping a mineral powder sunscreen onto your part. As a bonus, it works like a dry shampoo to soak up any extra oil."

PRO TIP: *Real Simple* magazine's Beauty Assistant, Jenny Jin, says, "When using a bobby pin, slide it into your hair wavy side down for better grip. Better yet, lightly mist it with hair spray or dry shampoo for an even stronger hold."

HOW TO NEVER HAVE "OLD" HAIR

Hair texture and quality can change as we age. Hair can become finer and more brittle. Hormonal changes and years of coloring and/or straightening your hair can also take a toll on the quality of your hair. While my aforementioned tips will help keep your hair at its best, when age is a factor there are steps you can take to keep your hair youthful and sexier. In the battle to look younger, one of the great developments of our generation is hair color. Our grandmothers had a choice of pink or blue hair color when their hair turned gray. Or shoe-polish black.

When I was born, my parents had a neighbor who took them under her wing because they had no other family in America. She became like my American grandmother because my real grandmothers both lived overseas. We have many pictures of her holding me as a baby. I look at those photos today and realize that despite her completely gray hair and glasses, she was merely fifty years old. She looked exactly the same when she was in her seventies. Her generation did not have the option of natural-looking, beautiful hair color, which would have made her look much younger. Add to this fact the now-outdated methods of wearing curlers and using lots of hair spray, and you realize how modern options now available to us can dramatically keep our hair youthful and beautiful at any age.

- While keeping your scalp clean is vital to having healthy hair, shampoo less often to help prevent breakage and over-stripping your hair of its natural oils and moisture.

- Use hair oil to add youthful moisture and sheen. Apply hair oil sparingly as a pre-shampoo conditioner or apply a few drops into your hand, rub your palms together, and run through your dried hair.

- Add hair masks into your hair-care routine once or twice per week. Hair masks are richer than your standard conditioner and add more intense moisture.

The Youthful Hair Test

Whether your hair is short or long, it should have movement. Stiff hair is old. Flat hair is old. Get a hairstyle that offers movement and texture.

Test your locks for youthful movement. If your hair is long, shake your head. If your hair looks disheveled after you shook your head, your hair has youthful movement. If you have short hair, run your entire hand through your hair, from front to back and then back to front. If your fingers don't get stuck in your hair, you have youthful, none-stiff hair. There are some exceptions to this rule: super-curly, buzzed short, or tight afros are exempt. For everyone else, if you failed this test, your hair looks older than it should, and it's time for a change!

- Gray hair can be beautiful and youthful if it's sleek and shiny, so use a gloss.

- When hair turns gray, it becomes more coarse and wiry and can yellow—all of which are aging. If you opt to embrace your silver, keep the color from yellowing by using shampoos formulated to remove the yellow. Oftentimes they're purple.

- Gray hair looks best when groomed, so get it trimmed every four to six weeks.

- Lighten the hair that frames your face. Making the crown of your hair lighter than the rest of your hair will brighten and add a visual lift to your face.

- Lighter hair looks like fuller hair. If you experience thinning hair, going lighter will help create the illusion of a thicker head of hair.

- Hair can be cut and styled strategically to help conceal thinning areas. Speak frankly to your stylist to assess and discuss the most flattering cut that address your personal hair issues.

- Because we tend to get so attached to our hair we often lose perspective as we mature. When you consider your hairstyle, think of your hair in relation to your entire face. Overly long, straight hair, for example, can drag down all of your facial features. It's important to know when your style is no longer working for you. If you've had the same cut and color for more than five years, it's probably time to revamp.

PRO TIP: *Good Housekeeping's* Beauty Director April Franzino says, "Apply dry shampoo at night and no one will be able to tell you haven't washed your hair (even for days!). Before bed, I spritz dry shampoo onto my roots, then brush it through. Any residue absorbs as you sleep, and you wake up with hair that looks and feels freshly washed."

Coloring Your Hair at Home Like a Pro

A friend of mine who is a renowned hair colorist tells me he feels guilty charging his clients who have dark hair for single-process color because he applies the color, lets it sit for ten or twenty minutes, and then rinses it out. It's simply a matter of selecting the correct shade, but doesn't require the artistry of, say, a double-process blonde.

If you are looking for an extreme change, like going from dark brown to blonde, leave it to the salon professionals, but if you are simply looking to cover some gray hairs or to make a change that doesn't involve adding highlights (like going from light brown to a redder shade), you can do it at home easily.

If you are reluctant to try coloring your hair at home, try a temporary hair color. They contain no ammonia and shampoo out completely after two to four weeks, depending on how often you shampoo. This is a great way to experiment and test your hair-coloring skills without too much of a commitment. This is an especially good solution if you want to test-drive a new shade.

There are many products available to touch up your roots between hair-color sessions. They are usually powder, fiber, or spray formulas and they shampoo right out. These products can be used in a pinch if you need a quick color boost or to cover gray roots for an important event. Choose a color that is a shade or two lighter than your current hair

color for the most natural-looking results. These products are intended to cover roots, not to use all over your hair.

On photo shoots, I've often concealed roots using my Golden Glow Eyeshadow on blondes and my Neutral Impact! Eyeshadow on brunettes.

Another trick I discovered is to skip the conditioner that is sold with at-home hair color for twenty-four hours. The hair color that would rinse away with the conditioner remains deposited on your hair. This allows the hair color to last longer.

Temporary hair color to try:
Clairol Natural Instincts, $5.99
L'Oréal Healthy Look, $6.97
John Frieda Luminous Glaze Clear Shine Gloss, $9.99

Touch-up hair color to try:
Clairol Root Touch-Up, $6.99
Oscar Blandi Pronto Colore Root Touch-Up and Highlighting Pen, $23
Toppik Hair Perfectin g Tool Kit, $24.95

PRO TIP: Beauty writer Mary Rose Almasi says, "Color markers and color sprays designed to cover up gray roots work better when you blow-dry them once they are applied. Apply to your wet, clean hair, then blow-dry as you normally do so they take on your hair's texture and the results look more natural. You are less likely to have either a weighed-down or a dull, matte look. Blow-drying erases the negatives!"

chapter nine _____

THE CLASSIC
DAY FACE

< Meet Our Model

LAUREN is the account executive at Ramy Cosmetics and is also my personal assistant. A perk of her job is stepping in whenever I need a model!

Makeup is a fun way to express your individual style, and the best part of that fact is that you can change it up every day depending on your mood. That said, there is a classic makeup application that looks nearly unmade-up and simply perfects your complexion and plays up your features. This is the look used by models on go-sees and actresses on auditions. The objective is to look polished and have your features pop while keeping the look clean. When I do a makeup lesson for a client, I always start with the Classic Day Face and then demonstrate simple, "Minimum Makeup, Maximum Impact!" steps to take the Classic Day Face into evening.

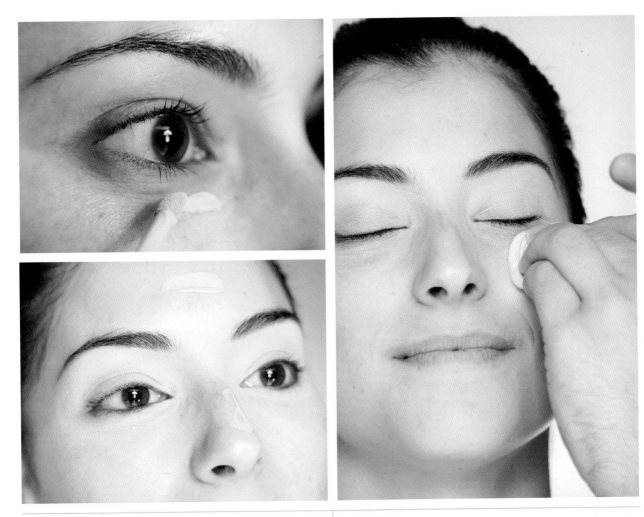

STEP ❶ : Prep your canvas by cleansing, followed by moist-
erizer and a primer.

STEP ❷ : Apply a concealer around the entire orb of your
eyes, including your lash line to your brow bone.

STEP ❸ : Set the concealer with a touch of pressed powder.

STEP ❹ : Apply a tinted moisturizer or BB Cream where
needed on your face. If your complexion is oily, set
with a pressed powder. If your complexion is dry, skip
the powder.

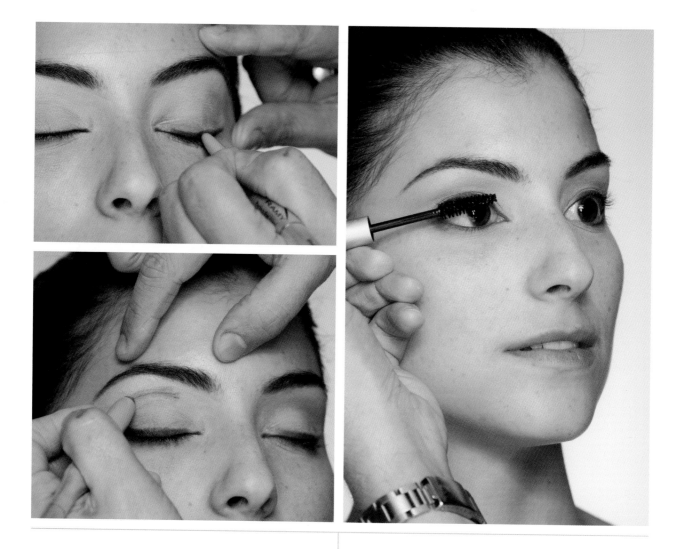

STEP 5 : Apply a neutral (taupe, gray) eye shadow to the crease of your eyes. Blend.

STEP 6 : Apply an eyeliner to your upper lash line only.

STEP 7 : Apply a mascara to your upper lash line only.

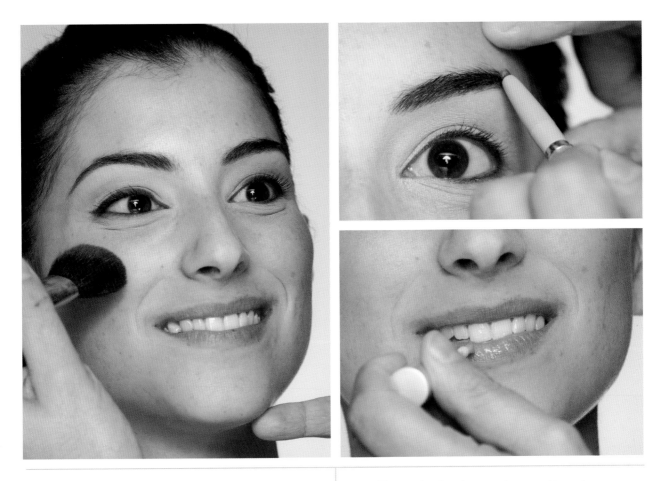

STEP ⑧ : Apply a nude or pale pink blush to your cheeks and onto the crease of your eyes, on top of the neutral shadow.

STEP ⑨ : Apply a lip gloss or a lip-toned lipstick.

STEP ⑩ : If needed, fill in your eyebrows.

PRO TIP: Bonnie Fuller, President/Editor-in-Chief of Hollywoodlife.com offers this emergency tip for when you forget your makeup bag: "In a fix, you can use your powder compact to powder your face well enough so it looks like you're wearing foundation. Then dot lipstick on your cheeks and rub it in to get a quick blush look. Finally, use the lipstick on your lips."

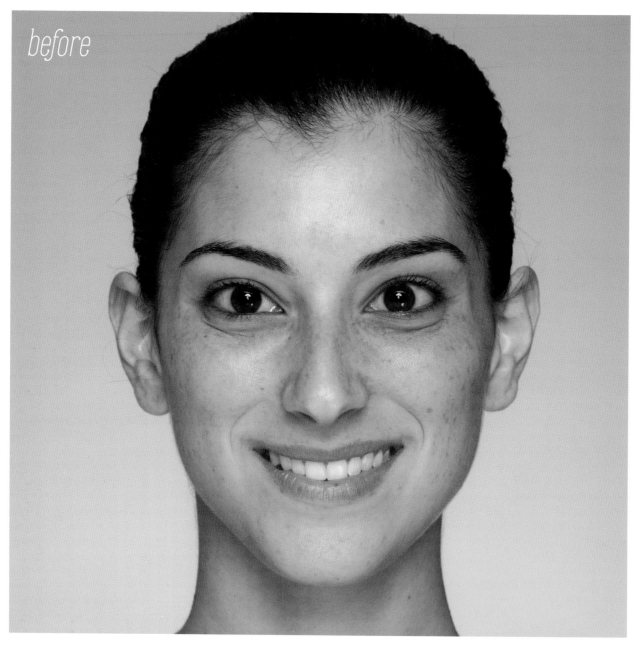

before

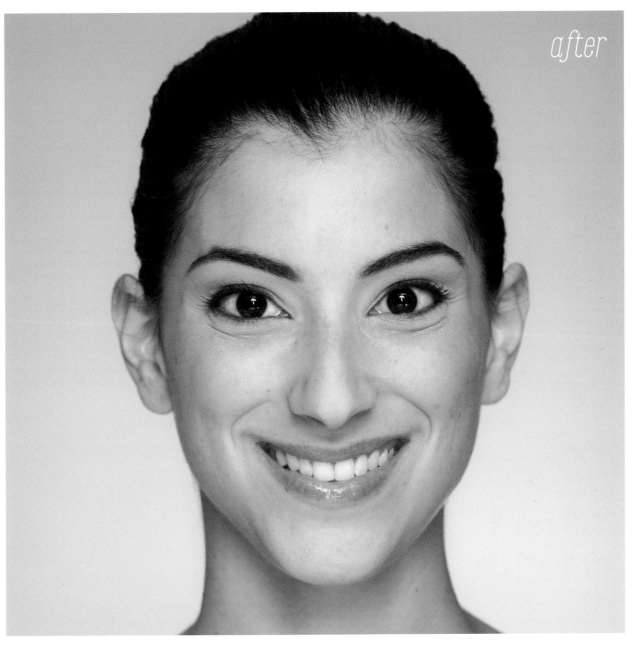

after

Day into Evening

Once you have applied the Classic Day Face, there are simple steps you can do to take this look into evening or to amp up your look to suit any occasion. Choose one feature and play up that feature. Either intensify your lip color and texture, or make your eyes more dramatic, for example.

Option 1

Take your lips from Day to Drama! You can either simply add a gloss on top of your daytime lipstick or, as you see here on Lauren, create a bold lip with a rich lipstick color. Add lip liner for definition and a more finished look, and top off with lip gloss to add glam shine.

Option 2

Highlight to re-texturize. Add a highlighter high up on your cheekbones to add a dewy finish to your complexion and play up your cheekbones. Blend it out and follow with blush to blend in any lines of demarcation from the highlighter. You can add the highlighter to tear ducts and/or eyelids, too. Blend. Follow with the highlighter on the center of your lower lip, then blend back and forth. If you're wearing a top that shows your shoulders or collarbone, you can blend the highlighter onto your skin to give it a beautiful sheen, too.

 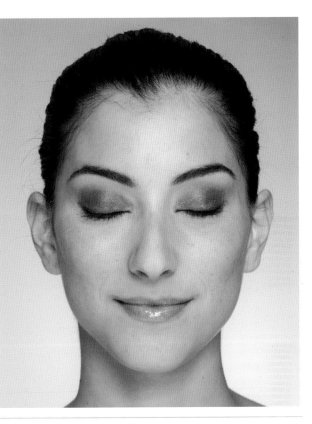

Option 3

Intensify your eyes! Amp up your eyelashes by either adding more mascara or applying a mascara revitalizer to thicken and lengthen your daytime mascara. Take the same eyeliner you used for your daytime look and make the line on your upper lash line thicker and extend it farther past your outer eyes. Add liner to your lower lash line and smudge it. Add the neutral eye shadow you used on the crease of your eyes to your entire eyelid and along your lower lash line, just under your eyeliner to create a smoky effect.

Option 4

If you want to add color to make your evening look pop, add any color eye shadow you want directly on top of the neutral eye shadow on your eyelids. Add this color on top of the shadow on your lower lash line as well. Add lip gloss on top of your daytime lipstick to top off the look.

AFTERWORD: LESS IS MORE

A subtle hand is what will make the lessons in this book yield believable, fresh-faced, natural beauty results. While I acknowledge that I'm known for doing great natural makeup—*Vogue* editors send me their friends who are afraid of makeup—I wholeheartedly believe that if your objective is to achieve results that will make people notice you and not the makeup application itself, you will discover that my advice will accomplish that. In closing, the lessons for glorious results are:

Build!

Whatever technique you are doing, start slowly and build from there to achieve the results you want. For example, whether applying bronzer or contour, begin with a light hand and add more in small increments until you achieve the look you're striving for. Slow but sure will create the best results.

BLEND!

With any and all makeup techniques, take a moment to blend. Slapping makeup on and running out the door looks like you slapped makeup on and ran out the door. The difference between an amateur and a professional makeup application is in the art of blending.

Be Objective!

Of everything I cover in this book, this is probably the most difficult thing to do. We all have very strong ideas of what we look like instilled in us from an early age, either by our parents or childhood bullies or simply our own insecurities. It's very difficult to clear these ideas out of our minds and look at ourselves objectively. If you can do this, you can give yourself an honest appraisal of what your best features are and what you might need to address.

Love Yourself!

Every one of us has something beautiful about us. I always say the secret to my success is that I fall in love with every face I work on. Everyone has features that they should play up and features to play down. It's the same equation for *everyone* on the planet. So while you're being objective and focusing on the things you want to change, love yourself

too, and focus on the features you like about yourself that you want to draw attention to. The one thing this book can't teach you is how to have a twinkle in your eye. That has to come from you.

THE MOST IMPORTANT BEAUTY TOOL IS AN OPEN MIND.

When I attended beauty school in Australia, there was a very pretty woman in my class. I asked her if she was already a professional makeup artist, and she said that she was actually a flight attendant. She liked to take makeup lessons every year or two to learn about new techniques or colors that she hadn't known about before. I told her she will probably be beautiful her entire life because she was open to learning new things to improve her appearance. Keep an open mind to the endless beauty possibilities available to you, and with that adventurous spirit, the possibilities will be endless!

Meet Our Model >

As charming as she is beautiful, LAURA is a great example of how a beautiful smile and warm eyes are your best asset, with or without makeup!

PRODUCTS AND TOOLS USED TO ACHIEVE THE LOOKS IN THIS BOOK

Except where otherwise noted, all products listed in this section are Ramy Cosmetics.

IRENA

Products

- Ultimate Therapy Cream
- Elixir Skin Conditioning Primer
- Skin Stick #2 HD Concealer
- Elixir Liqui-Powder Foundation in Porcelain Doll
- Pure Radiance Pressed Powder
- Blush in Alive!
- Pure Juice Highlighter
- Face Gloss in Sugar Glow!
- One Stop Shopping! Mascara
- Lipstick in Smile!
- Lip Pencil in Laugh Line!
- Perfect Brow Wand
- Lipstick in Chutzpah!

Tools

- Capra Blush Brush
- Sable Lip Brush
- Powder puff

CELESTE

Products

- Freeze Frame Wrinkler Relaxer
- Ultimate Therapy Cream
- Elixir Skin Conditioning Primer
- Skin Stick #2 HD Concealer
- Sleep in Beauty in Medium
- Perfect Brow Wand
- Matte Eyeshadow in Golden Glow
- Matte Eyeshadow in Neutral Impact!
- Perfect Eye Wand
- Pure Radiance Pressed Powder
- One Stop Shopping! Mascara
- Blush in Alive!
- Pure Juice Highlighter
- Blush in B.Slapped!
- 2Lips Liner and Gloss in Not That Into Hue
- Lip Pencil in Smile Line!
- Lipstick in Ramyred!
- Lucky Lip Gloss in Luck Be a Ladybug!

Tools

- Sable Eyeshadow Brush
- Capra Blush Brush
- Sable Lip Brush

LAURA

Products

- Ultimate Therapy Cream
- Elixir Skin Conditioning Primer
- Skin Stick #3 HD Concealer
- Elixir Liqui-Powder Foundation in Almond Princess
- Lip Oil in Orange
- Perfect Brow Wand
- Perfect Eye Wand
- One Stop Shopping! Mascara
- Blush in Alive!
- Perfect Lip Tint
- Lucky Lip Gloss in Lucky in Love!
- Juicy Cheeks! Sheer Cream/Gel Blush in Maya Papaya
- Pure Juice Highlighter

Tools

- Capra Blush Brush

DARIN

Products

- Ultimate Therapy Cream
- Elixir Skin Conditioning Primer
- Skin Stick #3 HD Concealer
- Pure Radiance Pressed Powder
- Elixir Liqui-Powder Foundation in Porcelain Doll
- Elixir Liqui-Powder Foundation in Almond Princess
- Blush in Alive!
- Pure Juice Highlighter
- Lipstick in Maya

- Lip Pencil in Laugh Line!
- Lucky Lip Gloss in Lucky in Love!
- Perfect Brow Wand
- Perfect Cake Eyeliner (upper lid)
- Perfect Eye Wand (lower lash line)
- White Eye Pencil in Prestige
- Pure Juice Highlighter (eyelids)
- One Stop Shopping! Mascara
- The Starlet false lashes by Kevyn Aucoin

Tools

- Capra Blush Brush
- Square synthetic eyeliner brush

KATELYN

Products

- Ultimate Therapy Cream
- Elixir Skin Conditioning Primer
- Skin Stick #2 HD Concealer
- Pure Radiance Pressed Powder
- Elixir Liqui-Powder Foundation in Almond Princess
- One Stop Shopping! Mascara

- OMG! Over Mascara Glitter & Liner
- Blush in Alive!
- Lipstick in Celebrate!
- Lip Pencil in Laugh Line!
- Perfect Brow Wand
- Perfect Cake Eyeliner

Tools

- Ramy Scissor
- Ramy Tweezer
- Browtility Brush
- Powder puff
- Capra Blush Brush
- Square synthetic eyeliner brush

BROOKE

Products

- Skin Stick #4 HD Concealer
- Sleep In Beauty Tinted Moisturizer in Dark
- Pure Radiance Pressed Powder
- Miracle Brow Dark
- Perfect Eye Wand (liner)
- Eyeshadow in Anita Cocktail

- One Stop Shopping! Mascara
- Pure Juice Highlighter
- Lip Oil in Orange
- Lipsticks in All His Fault! And Moxy!
- Hint of a Tint . . . In a Pot!
- Bitch Slap! Blush

Tools

- Powder Puff
- Browtility Brush
- Sable Eye shadow Brush
- Sable Lip Brush

TANYA

Products

- Ultimate Therapy Cream
- Elixir Skin Conditioning Primer
- Skin Stick #2 HD Concealer
- Sleep in Beauty in Medium
- Pure Radiance Pressed Powder
- When Hairy Met Sealy Tinted Brow Gel
- Perfect Eye Wand
- One Stop Shopping! Mascara
- Perfect Cake Eyeliner
- Lip Oil in Rose
- Matte Eyeshadow in Neutral Impact!
- Pure Juice Highlighter
- Blush in B.Slapped!
- Lip Pencil in Laugh Line!
- Lipstick in Buh-Bye!
- Lip gloss in Lucky in Love
- Eyeshadow in Daisy Dukes

Tools

- Sable Eye Shadow Brush
- Capra Blush Brush
- Powder Puff
- Sable Lip Brush

ANGELINA

Products

- Ultimate Therapy Cream
- Elixir Skin Conditioning Primer
- Skin Stick #3 HD Concealer
- Lip Oil in Mint
- Sun Smooched! Bronzer in Medium
- Pure Radiance Pressed Powder
- Blush in Alive!
- Pure Juice Highlighter
- Sleep in Beauty in Medium
- Perfect Brow Wand
- Perfect Eye Wand (liner)
- One Stop Shopping! Mascara
- Face Gloss in Sunlit Glow! (eyelids)
- Lipstick in Moxy!
- Lip Pencil in Pick Up Line!
- Lucky Lip Gloss in Gettin' Lucky!

Tools

- Powder puff
- Capra Blush Brush
- Sable Lip Brush

ASHLEY

Products

- Elixir Skin Conditioning Primer
- Skin Stick #1 HD Concealer
- Pure Radiance Pressed Powder
- Sleep in Beauty in Medium
- Perfect Eye Wand
- One Stop Shopping! Mascara
- Original Miracle Brow! Compact
- Pure Color Eyeshadow in Lucky Penny!
- Blush in Alive!
- Pure Juice Highlighter
- Lip Pencil in Laugh Line!
- Lucky Lip Gloss in Lucky in Love!

Tools

- Capra Blush Brush

LAUREN

Products *(for day)*

- Ultimate Therapy Cream
- Elixir Skin Conditioning Primer
- Sleep in Beauty in Medium
- Skin Stick #2 HD Concealer
- Pure Radiance Pressed Powder
- Perfect Eye Wand
- Lucky Lip Gloss in Gettin' Lucky!
- Blush in Alive!
- One Stop Shopping! Mascara
- Perfect Brow Wand

Tools

- Powder puff
- Capra Blush Brush
- Sable Lip Brush
- Sable Eyeshadow Brush

Products *(for night)*

- Triumph! Mascara Revitalizer
- Lipstick in Berry Kissable
- Lucky Lip Gloss in Luck Be a Ladybug!
- Lip Pencil in Pick Up Line!
- Elixer Skin Conditioning Primer
- Pure Juice Highlighter
- Perfect Eye Wand
- Pure Color Eyeshadow in Candy Tuff!
- Lucky Lip Gloss in Gettin' Lucky!

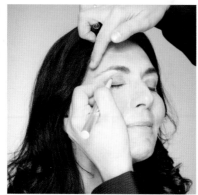

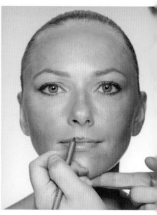

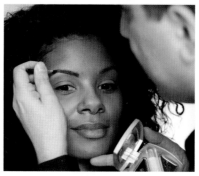
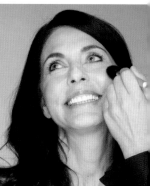

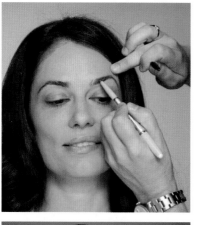

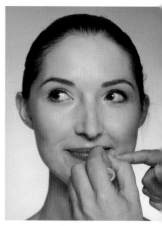

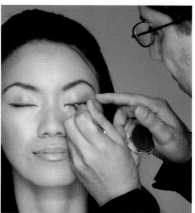

ACKNOWLEDGMENTS

Thank you to Cindy De La Hoz at Running Press for making this process so seamless and enjoyable, and Susan Van Horn for being so kind and having such a great eye.

This book would not have come to fruition without my literary agent, Linda Konner, who cajoled me for years to write it and get it done!

Thank you also to the wonderful experts who shared their knowledge: Nunzio Saviano and Jae-Manuel Cardenas for amazing hair; Polina Roytman for great styling and being the coolest chick ever; Dr. David Bank for all the dermatology information and always replying to texts, even though he's so busy; Dr. Jennifer Jablow for always making me smile and giving me a beautiful smile with which to do so; Anna Stankiewicz for all the great tanning advice and giving me an outer glow to match the inner glow; Carlos Chiossone for the great photography and eye for detail.

Thank you also to all the models in this book who were willing to be featured *au natural* so the world could see that even the most beautiful faces need the beauty equation to look their best.